Procreate for Beginners

A Step by Step Guide to Creating
Digital Art With Tips and Tricks

(Use the Procreate App for Digital Painting)

Frank Allison

Published By **Bella Frost**

Frank Allison

Procreate for Beginners: A Step by Step Guide to Creating Digital Art With Tips and Tricks (Use the Procreate App for Digital Painting)

ISBN 978-1-7779885-7-9

Legal & Disclaimer

The information contained in this book is not designed to replace or take the place of any form of medicine or professional medical advice. The information in this book has been provided for educational & entertainment purposes only.

The information contained in this book has been compiled from sources deemed reliable, and it is accurate to the best of the Author's knowledge; however, the Author cannot guarantee its accuracy and validity and cannot be held liable for any errors or omissions. Changes are periodically made to this book. You must consult your doctor or get professional medical advice before using any of the suggested remedies, techniques, or information in this book.

Table Of Contents

Chapter 1: Digital Painting In Procreate

Procreate is a computer-generated art software that artists use to make artworks, such as videos, images animations, as well as other art works. The program was developed by Savage interactive Ltd. Ltd it was launched on the 16th of March, 2011 for iOS as well as iPad devices. This means that it will only be used only on iPad as well as iPhone devices.

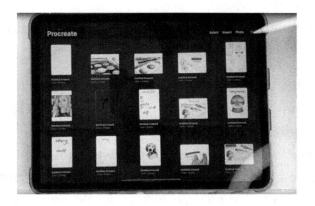

But, the majority of application is found in iPad gadgets because it provides the largest screen size and lets the artist be closer to their work. The experience is similar to painting in real life

using the Procreate application but the application comes with more tools that create art more easily. You will save yourself lots of time and effort through the use of creating. Certain features like drawings guides, color drops and drawing aid are built into the program for artists to unleash their imagination. Procreate is often referred to as the most advanced painting programs that has ever been created to be used on mobile devices. Procreate is built to work alongside it's iPad Pro and Apple pencil because it blends the experience of drawing traditional style and the capabilities that digital artwork.

With a robust layering system as well as stunning filters and thousands of fully importable brushes, Procreate allows the creation of high-quality work with lightning-fast speed. Additionally, the app allows pressure-sensitive drawing as well as Apple pencil and also iCloud Drive and a smooth recording of every stroke and makes sharing your work an easy task.

Digital painting is also regarded as a type of art which involves using various techniques, including brushes, oils or watercolors. and digitally. The process can be done with a computer, tablet, pointer and painting programs such as procreate, Adobe Photoshop, Corel Painter and ArtRage. This involves drawing on tablets or creating artwork using computers.

One of the greatest advantages of this painting is the ability to reproduce it with no errors in place of physical art. In addition, thanks to the astonishing performance and speed that computers are equipped with today It is much simpler to create your digital artwork. Computers are able to handle large files and offer different qualities that are precise and sensitive, handle quick brush strokes and, most crucially, all this in a matter of minutes with no lag.

Numerous artists are switching to digital painting since it's cheaper over time and essential in the fields of animations, illustrations, as well as 3D and 2D art. Digital

images allow the artist to draw directly on your computer with a variety of amazing advantages.

1. It's much less messy.

2. It's faster since there is no need to wait for the drying of paints.

3. It is possible to work wherever you go, all you require is a computer

4. Then you will be able to experience an entirely new realm of powerful design tools that can boost your creative abilities.

Procreate- Getting started

Procreate is simple to use in the event that you have a good understanding of digital painting. But if you're completely new to the digital picture, it may require a bit more time to get used to the application. It's a great choice to artists who are professional and contemporary. Professionals will find it extremely useful as they can swiftly bring all of their creative ideas in the application and make items with Apple pencil's powerful features. If you are just beginning to learn about the software it might

be appealing to people who are too sophisticated. It is, however, the easiest software for creating digital artwork that you will ever come across. The user-friendly interface allows you to pick different types of pencils easily, pick among a variety of shades, design intricate and complicated structures with the drawing guide and then share your work on diverse platforms.

One of the most essential tools the most out of the software can be the Apple pencil. It is a tool that can easily draw, sketch and paint using a variety of strokes and intensities.

Some Benefits of Procreate

Numerous digital art tools can be found on the web but the software cannot be considered as flexible in its functionality, variety, and efficacy of creating. There are numerous benefits that are

The benefits of having children are as follows:

Procreate is a great tool to create your animations: this is one of the more beneficial benefits of creating. There is no need to head to

the market and purchase a different program for your animation. Procreating comes with an animation feature integrated into the program that comes with 2D graphics. It's easy to upload the animation into your photo library.

Procreate lets you access the colors you want. When you use procreation the process, you can access almost all colors you'll need. It is not necessary to mix colors to create the other one, as you'd have to in the traditional painting session since all colors possible is available.

The Procreate application has an easily accessible adjustment section that allows you to make quick modifications to your drawing. It is possible to apply, remove as well as edit and correct your art by Procreate. It is all easy to apply. Nearly all adjustments can be altered using the built-in toggle bar to ensure that it doesn't obscure your artwork while you work with the.

It's so simple to use in comparison with other software for digital painting regardless of previous knowledge. It won't take much time before you get grasp of the. It doesn't require a

techie to utilize the application. This is due to the fact that it has simple controls and the creators even offer an online guide. It comes with a number of accessible functions with a clear structure that you can learn without the aid from a teacher.

Procreate comes with the brush studio, where it is possible to create customized brushes that are suited to your preferences It could be the tool you need to create your ideal artwork. The smoothness, gloss, sensitivity as well as the wicks of your brush, or those that you have already are aspects to take into consideration. It can even help you ensure your meetings are stable in the event that you have a jittery hand. The opportunities for meeting are almost endless. However, if that you aren't feeling the need to create your personal. If so you could transfer brushes to other artists, an additional one of Procreate's unbeatable benefits.

Procreate lets you manage your art more efficiently. This is one of the biggest benefits of Procreate since it allows writers to store all of their artwork using a gallery format. import files

from different gadgets. It also allows professional editing and create your work at a pace that is compatible with your creativity. It is always a benefit of taking your time because you can begin your project, then put it aside to work on later.

One of the benefits of procreate is its ability to allow seamless integration between different workflows. The user can toggle between apps in addition to a variety of platforms to access the files.

There are many other design applications that have a cost of up to $100 to use their application. There is also an annual renewal cost However, you can access the application at a low cost for the best design application. It costs $9.99 for a one-time purchase. It is not a charge for updates since the purchase includes life-long updates to the account you have on your Apple account.

You will also receive assistance at any time you're in need of assistance. A large number of people who have children is also a great way to seek out questions and receive responses.

Procreate lets you print and distribute your art in a variety of dimensions.

Making the switch to Procreate or beginning your career in digital art with Procreate is worth the time with these advantages.

Installing the Procreate Software

In order to start this digital art experience it is necessary to install the application installed on your iOS or ipadOS device.

Do this

Locate the Apple App Store within your iPad device, or go to the Apple site and search"procreating. Install the app by purchasing it onto your device.

Enter your password, and then agreeing to the conditions and terms.

Click on the search bar, and enter "procreate."

Click it, then click the blue installation icon.

Pay with credit card because you need to buy the item for $9.99

Include payment details and the payment method.

When you have completed the purchase you can confirm the purchase by entering the password.

The download process begins right away.

Once you have downloaded, go to open the program through the icon.

Apple Pencil and Procreate

Apple pencils are the primary instrument in procreate. It has many advantages including accuracy, speed and sensitivity, which makes your experience with painting appear more real. It's pretty simple to setup. After it has been connected to your iPad it is possible to begin drawing since there is no requirement for a second connection. The brushes built into the Procreate application can be used with the sensitivity and angles of an apple pencil. Apple pencils detect different amounts of pressure as well as tensions when you paint. It is the reason for the various degrees of thickness that are associated with various strokes. It is possible to

make a thin or strong stroke by using some pressure on it.

The pencil, in conjunction with procreate brushes is a tool that can create strange results. The pencil can be used with the Apple pencil for making your procreate entries.

With the app Procreate it is also possible to adjust the intensity of the Apple pencil. By doing this, you'll be able to choose the exact quantity of pressure that is applied on the pencil that creates various powers.

The best ways to utilize Apple Pencil to help you procreate;

Start the Procreate application then draw with a pencil. This is easy since it is not necessary to use any other pairing for using the pencil in create.

Be aware that the Apple pencil must be paired to your iPad for it to function successfully.

After you have accessed your software, you will be able to adjust the to the app's intensity.

How do I create Apple pencil's pressure

Find actions on the top left corner of the app procreate.

Click Prefs to open the tab to edit the pressure curve.

This will take you to a graph-like set-up. It is then possible to modify the curve to meet the preferences of your.

Chapter 2: Using The Procreate App

Procreate Interface

The interface of Procreate makes getting the job done more easily. Each feature can be found by simply clicking on them.

The interface for Procreate is composed out of three primary components that are: the painting tools, the sidebar as well as advanced functions.

Painting Tools

The paint tools on the top left of the Procreate application let users create a variety of drawings, cloning and erase. Additionally, you can add layers to create the effects you'd like to an image.

The features listed include:

Paint: It lets you pick your sketch, pencil or paintbrush to create the design. There is a large collection of brushes that you could utilize. Additionally, you can use external brushes as well as create your own customized brushes too.

Smudge: It's the tool that allows you the possibility of mixing colours in your art. Through this tool, you can alter and mix colors across different layers in order to produce additional effects to your artwork.

Erase Tool: This tool helps erase mistakes or attributes on your art work. This tool is used in conjunction with brushes. This means you are able to pick a particular meeting and then utilize it to create an error.

"Layers" feature allows you to include several parts to an image and modify them separately. This is a great tool when you have a complex image and may need to make particular adjustments to certain parts of the image.

Color: choose one of the colors from the vast selection of colors within the toolbox. Utilizing this tool, you can choose great combinations of hues and saturation.

Sidebar

The feature can be found on the left of the Procreate program, and is able to be moved to the right side as well. This feature lets you

reverse and duplicate actions on your images. Additionally, you will find Opacity and modifier sliders on this section. These sliders allow you to make fast changes to your art as well as adjust the brush.

The sidebars include these items:

Size of your brush: Used to boost or decrease the dimension of your brush. This allows you to easily change the tip of your brush in order to switch from thick strokes into thin strokes.

Modify:

It's the small rectangular button that is located in the center of the sidebar. You can select colours from your work using a single touch. You can then have them added to the brush.

Brush transparency: This second slider in the sidebar lets you alter the opacity of the brush. The slider can be adjusted to make your brush translucent or robust.

Redo and Undo arrows can be used to undo the actions you have made in your art. Utilizing this program, you can reverse up to 250 steps.

Advanced Features

On the left-hand part is the feature that's advanced. In this section there are menus for main features which include additional tools that ensure complete control when the process of procreation. Additional features include:

Gallery It is a space to manage and organize the entirety of your art work. There you can build folders for your pictures to be organized create canvases, upload and upload your artwork in various types of formats.

Actions Actions: This is the wrench icon that is located on the advanced features section in the procreate app. You can here modify your canvas, change the pencil's color, print your canvas, cut some aspects of your photo and then share the artwork.

"Adjustments." The subsequent menu, which is located under the advanced option within the Procreate application can be used to make adjustments on your photo to enhance the attractiveness inside the image. These tools comprise sharpen, noise the ability to clone and

liquefy. All of these tools can make your photo look stunning. effects.

Selections: Using this function, you'll be able to pick specific areas in your art that you can perform certain actions on the selected areas. It is possible to make selections with the help of freehand, automated rectangular, ellipse, or rectangle choices. They all allow you to make selections using different methods.

Transform: Provides the ability to draw or resize your photos to make interesting and distinctive forms for your images. In this way, you are able to later make additional adjustments to the vision you've created.

Modify your Interface

Procreate's interface was designed to function in the way you feel about it. You are able to customize it to fit your personal preferences and assist you in working better. Procreate has the light and dark interfaces. It is easy to toggle between the two depending on your surroundings or preferences.

To change your interface:

Click on the actions (the wrench symbol)

*Click prefs

Tap on the toggle for light mode to switch on the lighting mode.

It is possible to change the mode back to dark with this switch off.

The sidebar can be a function that is able to be shifted from left to right of the screen. This feature is useful for those who are left-handed and wish to manipulate the sidebar by using their hands.

For this,

Take the action

Click Prefs

Tap the left-hand interface

Brush Cursor

The cursor on the brush is the end of the "digital pen," From the tip of your brush will come the handful or thousand of brush strokes that are required for creating an art work. This

is why its component is essential for numerous users, as it can be found in every digital painting program. Brush cursor tools allow the user to paint over any surface, much like the real brush. Additionally, you will be supplied with various settings to choose from. You can adjust it according to different scenarios.

Gestures on Procreate

The most appealing aspect of procreation is how simple it is to operate. Contrary to other programs similar to Photoshop procreate was designed and designed to be used on iPad. iPad.

It's easy to use controls, speedy performance as well as a variety of gestures that you are able to make use of and customize to achieve the perfect work space. While doing this you let your imagination to take over. If you're looking to become a pro at procreating, these are essential actions that will help to become a pro at procreation.

Zoom out or in an emergency: the way you'd do it on every image within the Photos application, you could use a pinch-to-zoom feature to zoom

in and out within Procreate. This can be a great method for those working in drawings with numerous particulars.

If you'd like to expand your canvas the canvas, all you need to do is squeeze your fingers across your canvas.

If you wish to expand your zoom, you will need put your fingers in a pinch to the screen.

It is recommended that you took a snap to ensure that it matches the artwork on your screen. Additionally, pinching provides users with the aid to make your work look perfect on your display, regardless of the dimension of your device. However, it is best to pinch at the speed of light.

In order to place your canvas to your screen All you need to do is squeeze your fingers. If you'd like to go back to where the canvas was before, simply move your fingers in a pinch for a return to your original location.

Another step is to rotate the canvas when you are sketching something or anything the drawing should be viewed from various angles

in order to make it simple to make additional elements of your sketch. It's never more simple with the help of procreate.

When you want to rotate your canvas, all you have to do is place two fingers across the screen, and then twist your fingers around in an arc.

Two fingers to undo a mistake: to save yourself the strain of pressing the Undo button it is possible to erase any mistake you made using just two fingers. This can be done quicker. The only thing you need to do is tap with your arms across the display to erase the strokes you make that appear more recent. Press with your two fingers, to continuously undo the movements you've made.

Additionally, you could use three arms for re-doing it. It's the same as undoing. In the event that you wish to revamp some part of your drawing, all you have to do is to erase it. This can be done by tapping the display using three fingers. It is also possible to use the press and hold fingers in order to keep repeating what you've redrawn.

It is important to wash your canvas layers without difficulty: application of the eraser tool to wipe your canvas clean can be a bit challenging. It is a great thing to know that Procreate has made the process extremely smooth and simple to wipe clean layers with only one hand.

For this to be done, simply apply three fingers to your screen. Move your fingers in a circular motion just like you would scrubbing the floor. Continue this process until you've completed erasing every layer you have selected.

You can quickly access the cut copy and paste menus. With the aid of the amount menu, copy and paste which automatically pops up on the screen, you can easily duplicate and copy items.

Find your canvas and use three fingers to swipe downwards across any area of the screen. A menu that offers the option to cut, duplicate, cut, copy and duplicate. Copy all as well as cut, and paste. The menu will appear over your canvas.

Make four finger taps for full screen Similar to fitting your sketch to the screen by one quick squeeze or two, you could also create a as if it's a full-screen display, which is essential if your primary focus is in your canvas.

If you want to go full screen when the process of procreation, all you have to do is press using four fingers on the screen. This will cause the menu vanish. It is also necessary to see an entire screen on the upper right. If you want to switch back, press repeatedly with your four fingers.

It is possible to use the brush to erase The majority often you can utilize the same settings that show up on your screen to erase the sketch's particulars. It could create an amazing appearance or even shading. depending on the settings you have set up. For identical brush settings to your eraser, be sure to hold and press your eraser until you see a message saying erase using the brush currently in use.

Copy and Paste Menu

Procreate is a powerful software to use for artist, designer, or even as a hobbyist with a passion for creativity. This article will explain the menu of copy and paste in Procreate, we'll look at the different ways of how to copy and paste with Procreate. We'll also demonstrate the methods which are simpler to understand. Before we explore the other six methods Let's look into the basics of what copy and paste really about.

Copy and Paste is regarded as a term is used when it comes to computers. It has to do with situations where you want to copy an image, text, or any other item that was created digitally to put it elsewhere in the original artwork or art. If you wish to duplicate and copy a particular layer of procreate you can accomplish this by simply swiping left and selecting the "duplicate" button on the panel for the layer. This can be accomplished by another method: click on the copy icon in the settings of the layer before selecting paste from the wrench menu. One thing worth knowing is that, if you wish duplicate, copy and paste particular arrears "pieces" or your artwork

within Procreate, you can use the selection tool to pick the items, and then choose the copy and paste option from the settings general to you.

To understand what copying and pasting means Let's take a look at different ways for copying and pasting.

Procreate, the most speedy Copy and Paste shortcut methods to copy and paste when procreating aren't many however, there are a few. But suppose that you want to duplicate a whole layer while the process of procreation. If that's the situation, you'll need an alternative that utilizes three fingers in a row (your forefinger middle finger, forefinger, and your ring finger) Then, you can swipe downwards onto your canvas.

Pasting, copying and pasting a whole layer to procreate

Another method by which you could copy and paste the entire layer of procreation is

Choose the layer that you want to copy and after which click on it clicking on it and highlighting it.

The layer is tapped after which it will be open to the left side.

Select "copy".

Hit the wrench icon located on the upper menu bar.

Make sure the tab "add" is selected.

Choose "paste" and the copied layer will be copied into the menu for layers.

Select"copy and paste" or the "copy and paste" option found at the lower right of the floating selections menu. The program will duplicate and copy the particular component you've chosen.

How do I duplicate and then paste layers onto a canvas the process of procreation:

These are ways of how to transfer layers onto a brand new canvas while procreating.

If you want to duplicate and copy an existing layer before moving it to a different canvas, you'll have first open the layers panel. Then, select the layer that you want to duplicate.

Click on the layer and choose Copy, and then move to your brand new Procreate canvas, then select your wrench.

Make sure the tab "add" is selected.

Select "paste," and your copy will be copied in your layer menu.

How do you copy and paste an element on the canvas of creating

These are ways of how to duplicate and copy a single part onto a brand new canvas for procreation;

*Click on the select tool

Create a circle around the elements that you would like to copy.

Select the wrench tool, and then click "copy."

To open your newly created procreate canvas. Click to use the wrench, and ensure that"add" is the initial tab "add," is selectable.

Select "paste," and your copy will be transferred to a different layer.

What are the reasons you should learn to the copy and paste feature in Procreate?

Once one has learned how to copy and paste within procreate, it allows them to increase the speed of their virtual techniques for pix and art. It's one of the top methods of speed portray. This tool lets you rapidly create a one-of-a unique design without the need draw them the attention of every time into your work. This is also a fantastic instrument for creating repeated styles or backgrounds with no effort.

How can you see your canvas in a snap

In order to avoid mistaken strokes while viewing your work To avoid making accidental strokes, all you have to do is check it out in the library as soon as possible. In order to do that, while you're at your library, put two fingers across any canvas to expand it and view the work. It is also possible to tap the screen's right or left side to switch between the other paintings in your library. For a return to the library, put two fingers on the screen.

Customizing your Gestures

The best part of having children is the ability to modify certain gestures to suit your preferences. It is possible to make an exact gesture when that's the way you'd like it to be. So, it can not carry out the function which creates sets automatically. This is how it's been accomplished:

1. In your canvas, click on the Settings icon that is the small wrench at the right-hand side of your screen.

2. Click on prefs> Gesture controls.

3. Pick the manner you would like to tailor your gestures, and the things you would like them to accomplish.

There are many choices, and procreate has several options that can be switched off to make it easier. There are a variety of choices to the test by experimenting with each one to see which is most suitable to your needs.

Incredibly, these gestures can ease your burden and improve your effectiveness in the process of making. Keep in mind that you could alter

these gestures to ensure you can adapt them to the needs of your family.

Please note the following

To find the percentage bar that indicates threshold, scroll to the upper right corner of the screen and you'll find it in the bar for menus.

The Freehand Selection: The freehand method gives the user a lot of control over the selection you make. You can make straight and freehand lines to make your choices.

In order to use the freehand method All you need to do is trace lines with the using a pencil, or finger as in drawing.

You tap where you want the line to begin from after which you tap at the point you would like the line to finish to create a straight line.

If you wish to end an open spread, you will need select the point the spot where your selection began. Then you will see an arrow that indicates that you are on the right direction. One the most exciting aspects about the tool for freehand selection is the

possibility to use instant traces and freehand choices to help you edit your work as well as, if you lift your hand and/or Apple pencil, your selection won't be erased.

The Rectangle selection: applying this technique to paint You can create rectangle-shaped options in your work. The only thing you need to do is touch the screen with your finger. You can then move the rectangle until it is the shape and dimension you desire after which you can allow the movement.

In order to make an ideal rectangular shape it is possible to play with and drag the form using the two fingers.

The Ellipse option The Ellipse choice is as the rectangle-shaped choice tool. The tool allows the user to choose oval-shaped spaces. The only thing you have to do is tap on the display screen using one finger. move the ellipse to the desired size and length and then set it free.

If you decide to make your own perfect circle, draw and tap the ellipse with two palms, and then draw it across what you want to select.

Chapter 3: Colors And Brushes

Colors Overview

If someone thinks about color, the first thing that comes to mind first is the wheel of color. An ideal color combination with the correct paint can make the choice just as important as you'd like to think of.

Palettes

The term "palette" refers to an assortment of colors. The procreate palette library, you are able to make, save, share as well as create colors. The library of palettes does this by creating palettes accessible by navigating to any art work. In order to use palettes within

Procreate it is easy to do is tap on the icon for color in the upper-right corner and then add a new palette After it, click on the eyedropper tool in procreate and drag it across the color you want to put in your palette. Another method that is simpler to hold and tap the color you prefer until you see the eyedropper tool appear.

Picking Colors

When you do that you must make use of the Procreate color picker. When taking advantage of procreate's color picking tool then you must be able to follow these steps:

Press to hold your finger, starting from the area you would like to draw the color.

*You will see circles that are painted on paint.

Allow the color to appear through the color selector found in the top-right edge of the screen

Following that you are given access to use of the color you have selected.

The Eyedropper Tool

The eyedropper tool gives you the convenience of selecting the color that is already in your display can be chosen. You can also use it to make an image more complete.

What is the best way to utilize the Eyedropper to procreate?

For this, use the mod button on the left sidebar. In the opposite hand, press across the canvas to trigger the Eyedropper at the location you prefer and set it free to choose the color you want to use. After that, you'll see the brand new color display at the top of the loupe, and it displays the current color on its bottom.

Color Drop

Another useful time-saving method is to use the color drop function. The only thing you need to do is draw an draw a line around the space you wish to fill ensure that the form is fully closed and there are none gaps. The color circle can be dragged from the menu at the top of the body, filling the entire area.

Brushes Overview

Everything appears in your display is visible because a painter painted the image. A brush, for instance, can help you define what the button's background looks like the text's foreground, as well as the fill of a form. Brushes allow you to draw the user interface (UI) objects in any way from basic, simple colours to more complex set of images and patterns.

Paint, Smudge and Erase Brush Library

The Procreate paint brushes can only be used with the iOS Procreate app for iPad. The brushes won't function if they are used in photoshop or other editing and drawing software programs. They were inspired by traditional painting techniques and different mediums like acrylic paint, oil paint and gouache.

The user interface and the controls for the erase and smudge tools are identical to those of brush tools.

Make sure you know of the fact that the slider to adjust opacity for brushes and erasers will be the slider for strength of the Smudge tool.

But their options to customize however, they aren't the same. The smudge tool you are able to add a style your work or even soften edges.

The smudge tool that is texturized and different can be used to give different appearances and feel to your artwork.

The eraser tool offers the possibility of erasing with an eraser brush with completely different textures in comparison to the painting brush. This can make the area of the erase appear unnatural. Additionally, you can employ the same brush texture to paint and erase. This can be also an aesthetic choice to employ various brushes and erasers with different textures for an uplifting effect.

Additionally, you can move your existing setting for brush between the tool, smudge or erase. The only thing you need to do is hold and tap onto the tool to be used for transferring properties.

Types of Brushes

It should interest you to know that the procreate brush library contains 18 default brush types. This includes:

Sketching: This involves an assortment of pastels, pencils, chalk and crayons. They're more suited for people who want to sketch out their design with subtle touches of textures.

Inking: This brush was developed to recreate the motion and texture of markers and ink pens. This specific type of brush is an excellent option for ink-based, thicker drawings.

Drawing brushes give different variations of realistic textures to any sketch and are often utilized after sketching.

Calligraphy: The calligraphy library is commonly used by people who are using Procreate for callingigraphy and lettering.

Painting: designed to resemble paint brushes and create textures that can be built from medium brush.

Artistic: it refers to the selection of more ferocious and dispersed texts.

Airbrushing is the ideal tool to give any part of your artwork an airbrushed, glowing gradient.

Textures: Like the fine texture brushes these brushes hang on to the edges of patterns.

Abstract: Much like the brushes library for textures, this brush collection appears to be more abstract, and more patterned.

Charcoals: these are the go-to choice for many artists interested in creating. This brush library gives an appropriate amount of charcoal texture to every sketch.

Elements: is used to imitate natural elements. This brush library is also able to include natural elements to your artwork.

Spraypaints: Just like as the name implies The library is home to spraypaint brushes.

Touchups: Using brushes specifically designed to mimic hair and facial hair and even skin, this collection is useful for artists who work in portraits.

Vintage: This is an exciting brush collection that evokes the retro and pop art style of illustration.

Luminance: This brush library allows you to add an ethereal or glowing lighting to your work.

Industrial: This brush library has the greatest significance in relation to background components because it replicates the look and feel of tree bark, concrete as well as metals.

Organic: similar to that of the Elements brush library Organic brush collections is a recreation of earthly textures such as leaves, grass and cotton among others.

Water: This brush library was developed to mimic the combination of paper and water. this brush library helps make your drawings appear more real.

Organizing Brush Library

In order to organize your brush library It is important to organize your brushes according to style as well as medium. This way you'll never lose track of the location of your pencil,

paint or ink brushes are. Then, you create copies of the brushes that typically used and put them in one of the folders on highest of your list of brushes.

Duplicate Brushes

If you want to duplicate the brush all you have to do is swipe left, then select Duplicate. It is possible to reset the default brush by selecting this menu and also remove or share it if it is a custom-made brush.

Drag and Drop Brushes

When with the drag-and-drop brush all you have to do is touch the particular brush set that you're looking to open. Once you have done that, you are able to drop the brushes inside. Another way to use this method is to scroll across the entire list of sets using the use the fingers to look for the one that you're looking for. You can employ a different hand to grip the brush they are pulling.

Delete Brushes

To erase a customized brush set, simply tap the set to choose the option to delete it. When you've done this, tap again on it to bring up the menu options. After that, you click delete. To delete a brush that you have created you swipe left over it then tap delete.

Rename brushes

Renaming refers to changing the name for the brush set. for this, you tap it to pick. After that, you tap repeatedly, and it will bring up the option menu. Then you tap on Rename. Make sure you are aware that procreate cannot be renamed. default brush sets.

Create Brushes

To create brushes using Procreate, you must upload and download those new brush sets and brushes that are useful to the user. Browse the library of brushes, then press the + button to make the new brush.

Brush Studio

The Brush Studio ensures that your brushes will look distinctive, exactly like your artwork with its impressive array of customizable options.

Brush studio gives you an option to apply to existing brushes as well as the option to make a name for brand new brushes.

When it comes to approaching the studio for brushwork you have two options for doing it. It is possible to dive into the studio when you're looking to design and tweak settings until your goals are achieved. It is also possible to play playing with uncertainty, experimentation and exploration to create what appears to be excellent. The brush studio two ways:

Use a brush you already have to modify it, or press the + button for an entirely new brush.

Be aware that both alternatives will open the exact Brush Studio interface, with the exception of one thing. The import option can only be found in your Brush Studio by using the + button.

Streamline

Procreate streamlines the way you can achieve elegant, smooth and beautiful lines making procreation employing any type of brush of your preferred.

Visit the brush palette by clicking on the brush palette and then tap the brush.

Adjust the streamline until it is at its maximum when you set your brush find the path of your stroke and reduce the speed up to 100% until it reaches the highest level. You will see that all lines are been drawn with a graceful curvatures that are beautiful and elegant.

There are only two simple steps that you can apply to create sleek, beautiful, and beautiful lines using all the brushes you can find.

Drawing pads are an user-friendly whiteboard program which you can access whenever and wherever to work from home, or to have fun. It aids creative individuals search for new ways to express themselves to draw; it has incredible features, such as drawings, stickers, brushes forms, charts as well as others. The perfect team for the it possible to procreate can be

found in an iPad Pro and Apple pencil. When you are procreating, you may draw using your finger or with a stylus from a third party There isn't any alternative tool to match the speed and precision provided by Apple pencil. Apple pencil.

Importing Brushes

Importing procreating-related brushes into your computer is very simple. After you've downloaded the procreate brushes and want to upload it then all you have to do is open it in the "files" app on your iPad. Its icon is white and an blue folder for files. If your device isn't able to open it iCloud Drive, click on the "locations" option located at the top left corner then choose iCloud Drive. Click in"downloads. "downloads" folder. Locate the file for the brush that you're interested in making use of, then click it. It will then become procreating and imported and available for your make use of. If this is the first time you have imported brush, it'll create the "imported" section of brushes which will allow you to locate the particular brush that you transferred. If you

own an Mac or Macbook, you are able to make use of the AirDrop method to upload fresh brushes and generating. What you must complete is to download the file to your PC (Mac or Macbook). You then open the file and upload the file making use of AirDrop using your iPad. Procreate will then add the brush to your library.

Sharing Brushes

If you want to share a brush that you created, move your brushes between pads or even back up your sets of brushes, swipe left over the brush, then click the share icon, then select the place in which you would like your brush exported. The procreate will be saved to your brush in your image in the style you prefer.

Chapter 4: Texts And Layers

If you are just beginning to reproduce the idea of procreation, it's essential that you know how to utilize the layer menu. Layers let you stack images over them. This allows you to create images that cross-pollinate without altering what you've previously completed. Additionally, you can change, edit, recolor or delete objects completely free of limitation. Procreate included the text editor features in order to lessen the burden of people switching to various programs or exporting their files while making edits to the file. Procreate will also includes text editing tools right within the program.

Layers Overview

The layers that are produced during procreation come in two varieties, the first being;

Design Layers: it can be used to create and model models for projects. It includes drawing objects that can be placed in a stack, hidden, enlarged and then moved.

Design layers have the border of a gray stripe (whenever the border of the page is displayed) as opposed to the sheet layer which features a larger gray border that represents the margin of print. Because of this, you can clearly distinguish between each kind of layer in a glance.

Sheet layers: It was used to create an image of the drawing that was created. This includes titles, notes and various annotations.

You are able to organize the layers of design in any manner you like to arrange them, or you could hide a portion layers, but not completely. Modify the order in which layers are placed, and move every object contained in each layer into a different place without changing the objects or their arrangement to one another.

When you sketch the floor plan using two layers of design that include one vellum layer using a master drawing plan and the other with an additional to the software, it will be easy to take a look over the plan in the event that you create, or the decision not to use the addition. The Vellum sheet is digital inside the

Vectorworks program and that it can accomplish many possibilities with it. Instead of having your designs layers lay across them, they can span a distance

Beset between it. You should be aware that these layers could be viewed in 3D using the programs' capability to model. Take, for instance the house model as a custody model; in the event that the first and second floors as well as basement and the roof are set in their own design layers, you'll be able to see that it's not only the 2D draft plan which can be printed out for each layer. But, all the design layers may also be joined, creating full-form 3D models of houses. Viewports are a way to show different perspectives of the designs that have been constructed. It can be on the design layer (Vectorworks Design Series is required) as well as be placed on the sheets layers. It is important to note that the design layers are identical.

Layers can serve a variety of purposes and serve a variety of purposes. By using layers, you've the capability of moving elements from design

layers to another, they can be altered in the dimensions of layers as well as quickly draw a sketch of an area in your drawing, and not go through the process of drawing it over again. The coatings can also aid in the creation of designs layers through the use of items that must be displayed at all times or include things to be collected but only for certain times. It's important to be aware that layers regulate the display of designs layers, thereby reducing the requirement to create new objects. It is possible to use the Vectorworks Architect program is optional for design layers to be paired with stories that contain items; stories provide how to define absolute elevations within the construction model. On contrary, layers may be placed at an appropriate height in relation that is equal to. In the event that one utilizes this method to organize their files it is simple to handle the layers of a building and other objects related to it, including columns and walls.

You should be aware that the sheets are listed first before the design layer, which is on the list of layers in the view bar. Also, the separator

appears to separate the two kinds of coatings on the list.

Layers Panel Interface

The panel's interface speaks about the panel layer, that lets you add or remove, activate or modify layers which are associated with your model. The layers can be displayed as a stand-alone or alongside additional layers. In the panel, to handle the aspects that relate to the layer we are working on, from the addition and deletion of layers, to adding masks for layers and adjustment layers, changing the layer blend modes, switching layers in and out of the document, changing names of layers, grouping them, as well as any other task that involves layers. As it's one of the panels that are most commonly used within Photoshop, Adobe sets things to ensure that the layers panel will open automatically when we open the application. The panel for layers is located on the left-hand side of the graphic user interface. In the event that the layer panel isn't visible in your display. In this situation, you are able to access the panel (along other the other Photoshop panels)

simply by scrolling to the menu for windows on the Menu Bar at the top and selecting layers.

Creating a Layer

For creating a layer all you need to do is Double-click Background on the layer panel. Then, you may select layer>New>Layer from the Background. Set layer options. (see the steps to create groups and layers.) Make sure to click OK.

Organizing layers

The organization of layers is an important element to be considered while working using layers. In order to keep your layers in order it is necessary to make the folders for them known as groups. Then, you can join layers in the group, and later organize them however you prefer to arrange them.

Create a folder by clicking on the "Create a new group" button located at the bottom of the layer palette.

Drag and drop layers on the group folder layer in order to include them into the group.

Double-click the Group Name within the Layers Palette in order to change its name the group

Include texts

To include textual content to your website, follow these steps:

Find a picture as well as a Photoshop Document (PSD) Then select the file to start it.

Click on your toolbar and select the Type tool. Or it is possible to press 'T' to choose the tool at a rapid pace. Horizontal Type Tool, the ability to add text horizontally is the default. If you want to include text vertically use the Type Tool again and select Vertical Type Tool in the contextual menu.

If you would like to include a few words for example, like headings or title, then you'll need find a spot in the canvas before you enter the text. The text is often referred to as point text within Photoshop. Another kind of text you can use in Photoshop is referred to as paragraph text. It is used it when you need to compose an entire paragraph. In order to do that simply click and click and drag your cursor over the

canvas, creating the bounding box that you can use to write your paragraph. This allows you to modify and align your paragraph at a later time with efficiency.

Enter your text. If you want to save the changes you made make sure you click the option bar. Or, you could also hit Esc and you're ready to proceed.

Importing fonts into procreate

Once you know how to incorporate fonts into your the process of reproduction, it can help with enhancing your art work every way possible. What is the best way to incorporate fonts into procreating?

To accomplish this, you'll need to:

Buy a font There are many stunning script fonts at places such as Creative Market and Etsy. It is important to know that creating script fonts is not for those who aren't confident and many fonts require approximately 3-6 months to design and, therefore, if you want to buy just one font, you must be aware that lots of hard work will make your project appear attractive.

Unzip your files: First, make sure to unzip the font files. After that, you'll need to go to the second procedure.

Save your font documents to DropBox You can later take a look and save the fonts files to your DropBox.

Open a Procreate canvas Select the canvas you want to use and then open it. The dimensions and types are not important.

You can find the action panel: The panel for actions is situated at the very top left side of the toolbar and it appears as the shape of a wrench. Click it and after that, it will show "Add.'

Press 'ADD This should open the text tool. Text tool.

Tap "AA" at the upper right corner of the keyboard. By default, the keyboard will be displayed in order to allow you to start typing. Prior to that, go to the right and look for the button which appears similar to AA, then press it.

Select the import font A brand new screen with options for fonts will pop up. Tap the 'import font' icon found at the top left of the board.

Click 'Done': make sure you press "Done' in order to confirm that you're on the right track. then, the font will be added to the Procreate font library for life.

Import fonts using Drag and Drop

In order to import fonts with the Drag and drop method, it is necessary to open the file Explorer and find your TrueType (TTF) document. After that, drag it onto the panel on the display of fonts, which reads Drag and Drop to load. It is time to release your hold on your font as soon as you see the icon copy and then install it once that is complete.

Chapter 5: Drawing Guide And Assistance

Drawing guides can make drawing much easier. Let's take a look at the reasons to employ Procreate's drawing guides:

If you're not comfortable about the removal of brand new items Grids are an ideal way to sketch the latest thing. It is possible to draw an image of a model with the grids, filling every grid in the order you want. This method can ease the burden of the burden of figuring out complicated things.

Grids are always employed for aligning. This produces the perfect results when you use it for letters when you wish your lettering to have to be the same width and height.

The grids of perspective provide possibility to create a cityscape or landscape perfectly.

The symmetry grid is awe-inspiring using it since it allows you to draw anything that appears to be symmetrical in a short time, such as hearts or butterfly.

How do you make use of Procreate's Drawing Guide within Procreate?

The drawing guide is located within the canvas panel under the menu Actions (wrench icon located at the top left corner of the display.) To edit the drawing guide you must toggle the guide on. The option to toggle it on is off in the layer panel. If you create an illustration guide on a canvas, it will be able to recall the setting. The guide must be placed an assist on each layer, however. It is permitted to employ multiple types of guide on a single canvas.

Activating a Guide

There are many options for activating guides for the behaviour of your selection. If no activation method is chosen, the default will be programming-based; that is, guides could be activated through the Resource Center, and then it can be launched using a different guide by with the help of URL. You should learn that the options to activate your guide programmatically remain available even if different alternatives are picked. Automated, Badge and target Element activation is set within the activation settings of the bar of action. The Element is composed of the rules

defined by the settings for location in the guide's first step.

Automated activation: Once all of the requirements to display the guide are satisfied automatically, the guide will show in the guide's direction. Before the guide is installed, the requirements required for the Segment, Page and target elements and device type, as well as Guide throttle settings, and the localization setting are all met.

The default behavior of a guide already changed for "Automatic" activation (1) is not displayed to users after it has been removed by the exact user. It can be dismissed by using an the 'X' located in the upper-right area or an "ignore" button inside the guide. In the event that your guide is a part or special JavaScript which is able to override the default pendo function, you must be expecting your users to view a guide that has been set to "Automatic" activation until they close the guide.

Badge activation: badges let you place small icons next to the element on your site. Guides will be displayed after the user clicks the item.

This is a great option to incorporate an inline service to your application as your visitors will be able to ask questions in the exact moment they require they need it.

This approach allows users to open the guide when users click upon a specific element in the app.

Customizing a Guide

For you to customize your guide First, shut down the drawing guide and tap the buttons at the top of the toolbar. This allows you to toggle between various types of guides. The lower toolbar allows you to customize the guidelines you use. The only thing you have to do is choose an option, and the your default guidelines will be displayed on the screen with the option of adjusting them.

2D Grid

2D Grid 2D Grid has been used in two different ways.

In the beginning, it's utilized to aid in placement and spacing.

Second Thirdly, the Grid in conjunction with the assist drawing is used to sketch well-defined forms.

What can we do to make the most of the grid in 2D?

Choose two-dimensional grid Drawing Guide, and then go to your "Edit Drawing Guide" options option. There are four options for drawing guides in the lower right corner of the screen. Select "2D Grid" as your drawing guide.

You can then adjust the drawing guide. Then you will discover the additional options to your 2D Grid drawing guide. The initial setting is to deal with the color bar that is located on the upper right hand side, and it modifies the grid's hue.

Isometric Guide

Isometric guides offer you the ability to create the third dimension of your designs. This is crucial for architectural, engineering as well as other types of technical images. When setting an isometric guideline find the modified guide and then click on isometric. In order to edit the

Grid, tap on guide settings. The screen will guide you to the drawing Guides screen.

The isometric Guide will show in the form of lines, which cover your work. Then, you can alter the manner in which your Guide operates and looks. This can be accomplished through rotation. You can move the nodes around to alter the most prominent locations of the grid lines. The blue positional node rotates across the whole Grid across the canvas. Then the green node is used to rotate the grid lines. To reset the Grid back to its default setting tap any of the lines then press Reset.

Perspective Guides

The guide's perspective can be adjusted to provide the ability to adjust erase points. It has also been utilized to create realistic-looking objects as well as backgrounds for your art. All you need to do is set up and adjust your perspective guide, and in doing this, go to Modify>Actions>Guides and tap perspective. To modify the grid of your drawing, simply tap the Guide Settings. You will be taken to the drawing

Guides screen. Your view will then appear like a thin line which overlaid your work.

Vanishing Points

In order to create or include an vanishing line, all you have to do is tap any place on the screen in order to create the point disappear. You are able to construct as many as three points of vanishing, with the choice of a one-point, two-point, or three point perspectives. You can drag the individual nodes to change the angle of view guide.

One-point perspectives are also called the parallel perspective and it is the most basic kind of perspective. Every single surface that is in front of the viewer shows in their exact shape with no distortion. The horizontal and vertical lines run parallel to those of the canvas's edges as well as the art's horizon line. Only the edges which are oriented towards or away from the view that are distorting. The lines are all connected to one point that disappears. This is also known as the One-Point in one-point perspective.

The two-point perspective is sometimes referred to the angular view; it is the only vertical lines which are in a parallel. The horizontal lines of all kinds connect or two points along the horizontal line. Two-point perspective is more realistic view than one-point. It does, however, not offer the same detail as 3-point perspectives.

Three-point perspective is the most complicated but extremely realistic form of angle. In this case, lines are pushed closer to a point three points that disappear. This is similar to how we perceive the world devices receding away from us in all axes. The software provides systems for your artwork that are realistic in height, width and depth. height.

To get rid of disappearing points, tap on one of the factors that are vanishing, and press delete to take it off the factor, or you can also choose to swap the colour of the person or the vanishing point's books.

Symmetry Guide

Symmetry guides reflect your artwork over multiple planes to create amazing results. It is important to create and alter the guide to symmetry. To accomplish this, click under Actions > Canvas Click edit Drawing Guide. The screen will guide users onto your Drawing Guides screen.

Click the Symmetry button in the bottom left corner of your screen.

When you first open the symmetry tab, the vertical symmetry Guide will appear by default. The guide to symmetry appears in thin lines which overlay your work.

Drawing Assist

Each guide comes with the option of Assisted Drawing on the lower toolbar. By turning this toggle, you can enable Drawing Assist for your selected layer. are currently using, and is which is indicated by the assist tag in the layers menu.

The Drawing Assist force any drawing strokes to conform to your specifications and lets you create amazing perspectives with ease. If you

want to draw beyond the lines, you must turn the option to turn off this feature.

If you're desperate to gain more control over drawing Assist You can try the Gesture control options in the Actions>preferences menu.

Drawing quickly with a quick form

One of the most complicated and dynamic tools created by procreate was in the form of Quick Shape Tool. A lot of people including designers, illustrators, and graphic designers have waited for its release. In this tutorial I'll show you the way QuickShape is used bit by bit and demonstrate how to make use of it for your design as soon as you can without being intimidated. When you are doing this, it is necessary to follow these steps;

It is essential to choose the monoline brush in the Procreate Brush Library because it will demonstrate exactly how Quick Shape tool works. If this occurs that you aren't able to find anyone available, and it's not necessary to fret as you can take advantage from your Hand

Airbrush found in your standard Procreate Brush Library under Airbrushing>Hard Airbrush.

After that, you need draw a circle using the Apple pencil (but be sure to not take your pencil away at the conclusion) When this has been properly done, you'll be able to see that the circle you sketched earlier has been drawn in a perfectly symmetrical form. Be sure to keep the pencil in place; you are able to alter the size or rotation of your ring as you want in your drawing.

Next step is to raise the Apple pencil, and then click to edit the shape. It is possible to see the edit button only when your pencil is unable to reach the screen. It is located on the right side of the drawing. There are a few choices offered to pick from. However, it's all dependent on the type of shape you draw. For this project we draw the shape of a circle. We are provided with choices of Ellipse and a circle since the circle was drawn.

It is necessary to select the shape selection in edit section because this causes the anchor

points on your shape to be displayed. There are topics in each corner of

The form. The Apple Pencil to move or change each anchor point in order according to your personal style requirements.

You must draw a square, and then look at the unique shape edit options. This is everything we have done from the initial to the final step. However, you'll notice the non-similar options appear inside the edit shapes this time. The quadrilaterals or rectangle as well as polyline alternatives. You can alter the shape you originally sketched in the end. This can be useful for experimenting with a style which you aren't 100 percent achieved.

The following step is to draw your polyline, and modify it. If you're not satisfied using polylines, understand that they're just figures that aren't sealed. Lines that are continuous and connected to create different shapes and forms.

Chapter 6: Why You Should Use Procreate

Some of the benefits associated with Procreate are:

It is very easy to use

The app is also cheap to download and install

It enables the end-user to animate with ease

It also helps you to create brushes for easy painting

You can access friendly customer service agents

Saving your color palettes is very easy

The adjusting process will also not require a lot of time.

The benefits mentioned above place the app above its many competitors. You can start using it like a pro in no time, making it one of the best for beginners.

How to use an Apple pencil on procreate

You need first to activate Bluetooth on your device

Then launch procreate and create a blank canvas

You will see the entire interface element on the canvas.

Check the upper left corner of the app for a wrench symbol and tap on it

Pick your stylus type from the new window and hold the stylus for pairing with the app

Check if the app has all the settings needed for the pairing. The settings may differ across apps using a stylus.

App pressure sensitivity

You can adjust the pressure response of the Apple Pencil to suit your drawing pattern. You can access a wide range of pressure responses from the pencil, with the pressure changing as you press further down. To reach opacity or 100%, you must press down very hard. A lighter touch will give you access to a full range of the pencil's sensitivity via the default settings. You can adjust the feel of the stylus or pencil using

customizable App Pressure Sensitivity for Procreate.

How to install the Procreate Software

Launch the Apple Store app

Check the tab bar at the app's bottom and click on "Stores."

Look for iPhone Upgrade Program and click on it.

Continue swiping left until you can see the Procreate icon and click on it

Click on "Download now for free."

It will direct you to the App Store. Provide your password and click on Redeem. The download will start immediately.

How to Download and install Procreate on iPad

The basic version of Procreate is available for free download on iPad. In this free version, you can access all the essential features offered by the app, except a few. Upgrading to the Pro version will cost you $1.99. You can only

download the app on some iPad models, including the following:

IPad Pro 12.9 inch from first to fifth generating

iPad Pro 11-inch from first to the third generation

IPad Pro 10.5-inch

To install the app on an iPad, follow the simple on-screen information after opening the app for the first time.

Getting Procreate brushes

Open a new canvas and click on the icon for a paintbrush. This will open the Brushes panel.

Click on the folder into which you prefer to install the brush. Check the top of the brush sets lists or the + sign and click on it to create a new folder.

Downloading Procreate brushes onto you iPad

You need first to download. brush files to your iPad to help you add brushes to the app.

You can also access the new brushes from different websites online today

You must first download the Procreate brushes to your iPad and save them as a Files app. After that, you can share the brushes from File to Procreate.

How to use the Procreate app

You can start using the app by first creating a new canvas

The painting tools are located in the workspace's top-right corner

The brush slider helps to modify toll pressure and size.

Brushes are available in different colors from the brush library

You can draw by dragging your stylus or finger on the canvas

Chapter 7: Gestures On Procreate

Draw and Hold to access QuickShape

Open Full Screen by using a four-finger tap

Cut, copy, or paste by swiping with three fingers

Clear by scrubbing with three fingers

Redo by tapping with three fingers

Fit to screen via Quick Pinch

Rotate by pinching twice

You can zoom by pinching

Most frequently used gesture

Place the thumb and first finger on the drawing and drag them in opposite directions to expand the drawing.

After fitting your painting to the canvas using a quick pinch gesture, lift the fingers from the screen immediately for the best result.

You can undo a series of actions by tapping and holding two fingers on the canvas.

Single touch activation gesture

You can activate Single Touch Gestures Companion as thus:

Navigate to Settings

Then Procreate. Toggle on the Single Touch Gesture Companion

The gesture will show on the screen until you toggle it off.

The single touch gesture enables you to affect the following control using single Touch:

Undo

Redo

Zoom

Move

Fit canvas

Zoom using a single touch

You can zoom the canvas using a single touch, but you must first activate Zoom. After the activation, a blue line will appear from the canvas center to your finger any time you drag,

hold, or tap, helping to indicate the amount of in and out zooming.

You can zoom in by tapping and dragging away on the canvas. The reverse is the case when you want to zoom out.

Gestures for copying and pasting

You can copy and paste on Procreate using the three-finger swipe. You can call the copy and paste menu by swiping three fingers down the screen. The menu consists of the following buttons:

Cut

Copy

Copy All

Duplicate

Cut & Paste

Paste

You can also access the Copy Paste menu with a single gesture

Enabling QuickMenu

To enable QuickMenu, follow the steps below:

Click on Action

Navigate to Prefs

Click on Gesture controls

Click on QuickMenu

Toggle to the shortcuts to activate it

You can trigger QuickMenu using Touch if you are painting with Apple Pencil

Using the QuickMenu feature

Tap to activate QuickMenu. You can also pick any of its functions by Touch dragging it. The radial menu will come up and remain accessible until you select the option you want.

Touch-dragging will bring a faster result. Tap and hold your finger down, then drag the finger towards the desired button; release it to select it. Familiarity with the buttons' locations in the radial QuickMenu can quicken the pace.

How to customize Procreate

You can make your favorite tools easily accessible by setting six QuickMenu buttons. The buttons are:

Flip Vertically

New Layer

Clear Layer

Flip Horizontally

Merge Down

Copy

You can change any buttons according to the functions you need more frequently. To change it, open QuickMenu, then press and hold the button you desire to change. Scroll down the Action menu that comes up and tap the preferred one.

Creating a new project

You can start creating a new project by first creating a canvas. To create a new canvas,

Check the top right corner of the Gallery for the + sign and click on it

It will bring up the canvas menu

You also need to indicate the preset template you want. The templates are available in different sizes.

Creating a custom canvas is equally possible

Using a template

Install brush file

Hit the three dots at the upper right corner of the canvas

Click on export, then open end and copy to Procreate.

Click once to transfer the template.

You can also change the color as desired by clicking on the color palette from the top right corner of the canvas.

Changing the brush strength is equally possible from the menu at the top of the canvas.

Custom canvas

You can create your custom canvas if the preset sizes are not working for you. Click on the + icon to activate the New Canvas menu. Tap the rectangle having a + in the top right to produce the Custom Canvas screen.

You can easily adjust the following features on the canvas, including:

Name

Canvas properties

Dimensions

Time-lapse settings

Color profile

Using custom canvas screen

Chapter 8: Editing Or Deleting Presets

Open a present canvas and swipe left on it to enable you to delete or edit it. Enter the Custom Canvas interface by tapping the Edit button. On the Custom Canvas interface, you can easily adjust the attributes of the canvas and the maximum number of layers it can offer.

How to preview artworks

Check the Gallery toolbar for the Select option and tap it.

Select the artworks you want to preview; you can select multiple artworks simultaneously.

When the artworks are in the Selection Mode, a small circle will appear next to the artwork's name. Select the artwork you want and click on the preview button to take you to the preview mode

Organize your artworks in Gallery

When in the Select mode, tap as much artwork as you want to organize to select them.

Next, click on the Stack button,

You can merge artwork into a new stack by dragging and dropping the artwork thumbnail to another one.

The artwork's color will change to blue upon dragging the first one over the second one.

How to share, delete and duplicate

Swipe the thumbnail of any artwork to the left to help reveal any of the actions, like duplicate, delete or share. After you delete an artwork, you can never recover it again. You can share with ease to different locations, internal and external. The duplicate will appear on the canvas, and you can modify it as you deem fit.

How to organize the artwork

Organizing the artwork means you can arrange it as you wish on Procreate. You can move the artwork around very easily when organizing it. Lift out any of the thumbnails by tapping and holding them. After lifting it off the grid, you can drag it to any location of your choice and drop it there.

It is possible to organize multiple thumbnails simultaneously by selecting one canvas and clicking on another to pick it up.

Rotating an artwork

Rotating the artwork means changing its orientation, and you can do this by changing the canvas' orientation after creating it. Follow the steps below to do this:

Fix upside-down and sideways canvas previews.

Place two fingers on the thumbnails and hold down. Rotate the fingers until you have moved the artwork to the desired orientation.

Recreate an artwork

This has to do with giving the artwork a new name. You can do this from the thumbnail of each artwork you want to rename. Under the thumbnail you want to rename, you can easily see a box where you can type the title. If it is new artwork, the default title will be "Untitled Artwork.

Tapping on the title will activate the keyboard, and you can now change the name as desired.

How to create a stack

You can use either of two methods to create a stack:

Method 1: Use the Select mode

When in the select mode, select multiple artworks by tapping them.

Tap the Stack button after that

Method 2: use drag and drop

Drag and drop one thumbnail on another to merge the two into a new stack.

The bottom of the artwork will change to blue after dragging it on the other one. Color change to blue enables you to drop the artwork on top of the base to form a Stack.

How to add the artwork to a stack

You can add the artwork to a stack using the method described above. This time, you will need to hold the thumbnail at the top for some moments until you see the Stack flashing blue twice.

The Stack will then open, enabling you to add the artwork to it. It is equally possible to stack several artworks simultaneously using the bulk artwork actions.

Moving artwork from a stack

Follow the steps below to do this:

Enter the Stack by tapping it

Pick up the artwork you want to move out of the Stack. Remember that you can pick multiple artworks at a time.

Check the top left corner of the canvas of the return button of the Stack and tap on it using another finger.

Drop the artwork into the Gallery

You can also bring the artwork back to the Gallery by dragging them over the stack return button.

Chapter 9: Overview Of Layers

Layers allow the designer to sack image elements on one another. They also make it possible to paint overlapping objects without negatively affecting the work already done. Layers permit the designer to perform several other activities, like deleting, re-coloring, editing, and moving elements. It gives you complete creative freedom.

Creating new layers for each project is easy, and end users can access three layers. Despite placing objects on one another on the layer, each superimposed object or design will still exist independently. While it is possible to superimpose layers, you can always separate each of the superimposed layers when you feel like it.

How to use the selected layers

To move a layer below or above another layer, the tips below will help you:

Navigate to the top-right corner of the canvas to locate the Layers menu and open it. The

Layers menu is represented by the two squares superimposed on each other.

Next, press the layer you are interested in and hold it.

Then, drag the layer to place it below or above any other layer.

If you need to show the content of the lower layer, you may have to move the one placed on top to reveal the content below. You can also move a layer to a different canvas entirely.

Choosing layers vs. choosing contents

To select layers in procreate, follow the steps below:

Navigate to the toolbar at the top of the canvas and open the layers tab

Select any of the layers you prefer

Swipe right on each of the layers you want to select

You can swipe right again to deselect unwanted layers

You can use the Ellipse, Rectangle, Freehand, or Automatic settings to choose or select a single content. You can access all these settings in the Selection tool, which is presented as an S icon on the top toolbar. You should consider the closeness and size of the object before choosing any of the settings.

Adding texts

The steps below will guide you:

Open the Edit mode and pick the Text tool. You can find the Text tool in the top toolbar of the panel.

Click the area of the canvas where you want to place the text

Next, click the text marquee and drags it for repositioning anywhere on the image.

You can now drag the handle of the marquees for easy resizing.

Click on the text box and type the text in it. A new text layer will appear every time you add another text box.

Pick a font from the drop-down menu in the Context bar. You can also choose color, justification, and italics for the text.

Styles editing panel

Add a text to the canvas and modify its font to satisfy your desire. Tap on the text twice, and this will activate the Text Entry Companion. You can now open the Edit Style panel by tapping on the name of that chosen font in the Text Entry Companion.

Once completed, tape outside the text, or you can edit the other layers to help close the Edit Style panel

You can open the Edit Style panel whenever needed by tapping on the text twice to open the Text Entry Companion and then tapping on the font name in the Entry Companion. The Edit Style panel will give you complete control over features like:

Attributes

Design

Style

Font

Layers interaction

Contents on layers are opaque, covering up the layers under them. You can, however, create an interaction between the two layers and blend them. This is possible via the Blend Modes, which brings many possibilities to life.

To change the blend mode, navigate to the top right o the interface and tap the double rectangle symbol to open the Layers Panel.

Check the right-hand side of each payer for one or more letters that will indicate the active Blend Mode on your layer. The Normal mode is active by default and indicates this by showing the letter N. The Blend Mode features two parts: the opacity slider and the name of the current Blend Mode.

Chapter 10: How To Pick Colors

Procreate comes with the paint bucket tool and eyedropper to make design and drawing easy. The tools also ease the access for selecting a color already on the screen and filling an image. Beginners may find it somewhat challenging to use. The drawing tool on Procreate is similar to many other drawing apps. End users may, however, find it difficult to locate the tools, especially if they are first-time users.

Several situations can cause you to need the Procreate color picker while using the tool. You can even use it to pull a color from an earlier used image.

The steps below will guide you on how to pick colors in procreate:

Press any of your fingers (preferably the index finger) to where you want to pull the color from and hold the finger down.

A circle will take on your preferred color.

Allow the color to appear on the color selection tool located in the top-right corner of the screen.

This will give you access to the color you selected.

You can also use the color picker to create a palette manually. The process is simple, but it may take a beginner some time to learn how to use it. Before the manual color palette use can be possible, you need to create a different layer for housing the palette colors for the color picker on Procreate.

RGB color mode-default option

Printers and screens differ in the way they handle color. The color profile will enable you to create your artwork, helping them to shine in both formats. You can access the color profiles when you are creating a custom canvas. Check the top right corner of the procreate Gallery for the + icon and click on it. You can then access the Custom Canvas interface by tapping the rectangle with the plus icon.

The app comes with several pre-loaded standard CMYK and RGB color profiles, and you can choose any of them whenever you want to create a custom canvas. Procreate comes with

six RGB profiles, five industry-standard sRGB profiles, and a phone Display P3.

The app features several industry standard CMTK profiles, each based on common printer settings for the print artwork. You can also access extra-saturated oranges, reds, and greens on the P3 canvas.

Digital art can be created to suit printers or screens but not two at a time. RGB works for artworks that can be viewed on screens since it similarly manages colors as screens. RGB helps to break the colors down to red, green, and blue (RGB).

Artworks you plan to print should be designed using CMYK. CMYK breaks the colors down to black, yellow, magenta, and cyan. All the colors match the four ink colors in commercial printers.

Using Brushes

A brush in Procreate comes with Grain texture in a Shape. Each time you draw a line or stroke using the brush, you will drag the texture and shape along. You can use the brush to erase,

smudge and paint in Procreate. It also works for inking and sketching. The app will give you access to hundreds of highly versatile brushes to make your design experience wonderful.

You can use the brush to paint with rich texture and create calligraphy. You can keep your brushes in perfect order by organizing and storing them when they are not in use so that you can easily access them when you need them next time.

If you are unsatisfied with any of the brushes available on Procreate, it is possible to import some other brushes to the app. The app also permits its end user to share their unique brush creations.

The brush library is organized into themed categories, giving easy access to hundreds of brushes. Each brush offers a unique artistic experimentation opportunity to the end user. The brush button looks like a paintbrush, and you can find it in the menu bar at the top right corner of the app's interface. You can activate the brush tool by tapping the brush button

once. You can bring up the Brush Library by tapping the brush button twice a row.

Chapter 11: Organize Brush Library

You can organize your brushes according to the project you are handling. If you need to use a similar set of brushes several times over, you should organize them according to the projects you want to use them for. This way, you will not have to go through the annoying process of navigating your folders each time.

You can also organize the brushes according to the frequency of use. Your brushes should be organized so you can easily locate them.

Using duplicate brushes

You will need first to make your own copy or duplicate to ensure complete control of the contents when you want to customize a default brush set.

There is no way to rename or delete the default brush sets. Deleting the default brushes from the core sets is also impossible. Nevertheless, you can create a customizable version of Procreate brush set.

Tap on any set to be edited and click on Duplicate. This will create an exact copy of that

Set below the original. The two brushes thus created can serve the same purpose too. However, it would help if you kept them organized for easy access to each.

Renaming your brushes

You can name your brushes in a way to make each of them easily assessable to you. The naming should be based on the brush's vibe, use, project, medium, or style. See to it that the name you give to each brush perfectly describes its purpose for easy reminding.

Each brush comes with a name from the Procreate developer, but the names are not written in stone; you can always change these names to ones that are more acceptable to you. Follow the steps below:

Open the brush library and locate the brush to be renamed

Tap on that brush to access its settings

Next, tap "About this brush."

Activate the keyboard by tapping on the default name of the brush

Give it a new name and tap Done.

How to create brushes

Set the brush source from the brush icon from the Brush Library and select the + sign. You can modify its appearance from the Source section o the brush; it enables you to change the Grain Source and Shape to determine how the brush finally looks. You can Insert a Photo, Swap from Pro Library, and Grain or Invert the Shape of the panel.

Adjust the settings as you desire from the Advanced Brush settings. The adjustment can always be changed.

Experiment with the new brush you created from the main canvas. You can then adjust further from the Layers menu.

Brush Studio

The brush studio guarantees that the brushes will remain unique thanks to its impressive range of customization options.

Brush Studio makes it easy to create new brushes. You can build something new or modify existing brushes here.

Open the Brush Library by tapping on the brush button

Check the top right corner of the screen for the plus sign and tap on it. This will take you to the Brush Studio.

The Brush Studio interface has three parts, which are:

Drawing Pad

Settings

Attributes

You can access the attributes from the left-hand menu, where you can also tweak the settings. The live update result is easily accessible from the Drawing Pad.

Settings and preferences on the drawing pad

You can preview the brushes you have created from the Drawing Pad, and it will show you the

changes without taking you out of the Brush Studio. The Drawing Pad stands as a preview window for the newly created brushes. You can also refer to it as a notepad for testing your markers' color.

The Drawing Pad is inside the Brush Studio and allows you to test and preview the changes to your brush. You can access how the brush responds by scribbling and drawing shapes into it.

You can activate the settings by tapping on the square-and-pencil icon from the top left of the Drawing Pad. This platform enables you to Reset all Brush Settings and Clear the Drawing Pad.

Import brushes

To import new brushes, follow the steps below:

Open the Brush Library and tap the plus sign to help you create a new brush.

Check the top right corner for the Import button and tap it to enable you to import a

brush from the .brushset or .brush file, which you can find in the Files app.

This will add an imported Brush Set to the top of the Brush Library

New brushes can be imported from outside the Procreate app too.

Locate the source of the new brush on your device and tap on it to import it into Procreate automatically.

This will create a new folder, Imported, where the newly imported brushes can be stored.

The newly imported Brush Set will appear at the top of the Brush Library.

Export brushes

Follow the steps below:

Swipe left on the particular brush you want to export

Three buttons will appear after swiping left: Reset, Duplicate, and Share. Click on the share button to export

Clicking on the share button will save the brush as a .brush file in any location you want to export. You can choose any location to send the brush to be exported. Choosing a location will help you to re-access the brush in the future easily.

You can export single or multiple brushes too simultaneously. To export multiple brushes, tap twice on the folder name, and the share button will appear.

Chapter 12: How To Import Fonts On Procreate

Procreate comes with several fonts, but you can always add more fonts if you want more design options. While the number of fonts on Procreate is few, the iOS system has up to a hundred fonts that can work for your designs and art. You can import any of these fonts from the iOS device to Procreate.

The iOS system offers both professional and playful ranges of fonts for designers, some of which are type-based, cursive, handwritten, and capitalized. While iOS has so many fonts, note that the number of fonts you can access on your iPad depends on the version of the iPad you are using.

Locating the fonts on your iPad will not be difficult; you must type something on your document and tap on the Edit Text panel to see the list of fonts.

You can import fonts in Procreate via several methods, which are highlighted below:

Procreate interface

The File App

Drag-and-drop

Import fonts directly from the Procreate

You can do this via AirDrop, and we will describe the steps to follow below:

Before proceeding with this step, determine if AirDrop is active on your iPad and computer.

Launch Finder on your computer and locate your font files

Select one or more font files

Control-click on them and then click on Share. Next, click on AirDrop. Look for your iPad from the list and click on it.

You will see a popup window asking you the location to open the file. Look for Procreate on the list and click on it.

Your font file will come up immediately in the font section of the Procreate Edit Text Interface. It will then be ready to use.

The method below can also help directly import fonts from Procreate:

Tap on Actions

Click on Add

Then Add text and edit the text to anything you find suitable.

Tap on edit style

Import font. This permits you to browse through the Files app to access the folder where the font is saved.

Tap on the folder to import it, and it will appear on the list of Fonts in Procreate.

Import fonts from the File App

Launch the iOS File app

Locate your fonts folder

Tap on your preferred font and hold it down with one finger

Use another finger to tap On My iPad, then Procreate, and Fonts Procreate stores all the fonts imported in this file

Drop the imported font into the folder and install it.

The file app option of importing fonts makes it easy for Procreate users to easily access fonts from their iOS devices, especially the iPad, to the Procreate app. You can also easily share virtually any fonts on the iPad with your Procreate app, enabling you to use those imported fonts on Procreate and your iPad.

You can import different fonts from your iPad device to Procreate, ensuring your font options are not limited to the default ones on the app. The default fonts are Jack Armstrong BB, Impact, and Eina. This will give you more editing options and make your projects more beautiful.

Each of the fonts can also have specific applications. It may require some experience to make the right choice among them.

Import fonts using the Drag and drop method

This method enables you to drag any font from the iPad Files app to Procreate

Launch the iOS Files app from Split View

Locate the font folder

Drag and Drop any font of your choice from the Files to Procreate. You can easily find the new font in the Font list.

The fonts available on Procreate are great but may sometimes be insufficient. The Eina font is a neutral sans-serif font. It is readable and clean, making it a good font choice for professional-looking designs. It can also work well for your simple designs.

The impact is one other Procreate font. It is bold and can catch the attention of those who see your designs. As a result, it can work well for your signage and header designs. Some designers are also known to use it for normal letterings if they wish to grab attention easily.

Chapter 13: Animation

You can animate if you can draw, which is made possible by Procreate Animation Assist. The app enables the end users to create beautiful animation by making a few sequential changes. It can help create movement and bring about illustration to life.

Turning on Procreate animation assist

It is very easy to turn on the animation assist on Procreate. Follow these steps below to get that done:

Launch the Procreate app

Navigate to the top left corner of the app and look for the wrench icon, which represents Settings. Click on it.

Look for Animation Assist under the Canvas option in the list of settings.

Enable the feature by toggling the slider.

The frame option menu controls the settings affecting individual frames in your animation. You can also easily change the settings for the

Animation Assist interface and the entire animation.

Duplicate and delete frames

Animation timeline gives access to frame options like Delete, Duplicate, and Hold. You can access the frame option by taping a frame in the Timeline and tapping it again. Follow the steps below for information on how to duplicate or delete frames.

Open the Frame Options

Click on Duplicate to create a copy of your frame in the timeline.

Tap on Delete to get rid of the frame

You can undo either by taping with two fingers at once.

How to share your animation

Procreate enables end users to share and export their animation in different formats, including MP4, PNG, and GIF. You can start the process from the wrench icon at the app's top left corner. It is also called the Actins button;

you can share your animations by tapping on it and then tapping on Share.

Check under the Share Layers section of the share menu for the three formats ideal for animation exporting. Each of the formats uses the layers differently. The exporting will only be possible with visible layers. Each of the formats also provides different benefits. The animation process is very easy, but a beginner may require some time to learn.

Add a foreground to an animation

This feature allows you to create a locked-in floating foreground layer for your animation. The foreground will lock a frame into a place to make it a consistent foreground element. The foreground will also show above all other frames in your animation.

Check the rightmost frame in the timeline to activate the Frame Options. Then tap on the Foregr0ond toggle.

The rightmost frame can only be assigned as a Foreground. It is also possible to only have one

Foreground at any particular time. You can set a frame as the Foreground by moving it to the rightmost position. Every other layer created after that will show to the left side of the Foreground, and you cannot move the layer past the frame.

Adding a background to your animation

This feature enables you to create a locked-in background underlying the layer for animation.

The background feature will lock the frame in place, making it a consistent background element. The background will then appear under all other frames of the animation.

Open the Timeline and tap the frame leftmost to launch the Frame options

Tap on the Background toggle next

You can only assign the leftmost frame as a background and can have only one Background at once

Move any of the frames to the leftmost position to enable you to set it as a background.

Every other layer you later create will show to the right of the background frame.

Skinning onions and adjusting animation settings

This setting shows semi-transparent copies of your drawings on both sides of the frame. The function allows the end-users to see an overview of the animation surrounding the current frame. The frames beside the current frame look almost solid, while the ones further away look progressively more transparent.

You can set the number of frames appearing in onion skinning by dragging the Onion skin frame slider. You can adjust the onion skinning to None to show only the current frame. You can also push it to the maximum of 12 surrounding frames.

You can set the onion-skin frame transparency by dragging the Onion skin opacity slider. Setting the onion skinning to 0% will make the other frames invisible.

Chapter 14: Drawing Guide And Assist

How to customize a guide

You can easily draw a guide in Procreate with assisted drawing. Follow the steps below to customize a guide:

You need to first enable drawing guides from the Actions menu

Choose the drawing guide you are interested in from the four available drawing guides, which are 2D Grid, Isometric, Symmetry, and Perspective.

Modify the grid size using the Grid size slider

Customize the guideline using the thickness or opacity sliders available on the bottom toolbar. The Hue slider on the top toolbar can change the guideline appearance.

Guides for rotating and positioning

Positioning in Procreate can be done using the blue node while rotating can be done using the green node. Drag the Rotation node to turn the content in any direction you like. The content

will rotate on its axis, and the readout will show the rotational angle as it changes in real time. You can also complete the positioning using a simple touch control to transform the image's shape and size.

Positioning and rotating

The posting can be done effectively using the transformation node. You can find the node on the corners and midpoints of the bounding box. You need to drag a midpoint node to squash and stretch the selection along a single axis, but you can also get a faster result by dragging a corner node to resize the content along the two axes simultaneously. In addition, you can rotate any content at a fixed 45 degrees clockwise by taping Rotate 450.

Isometry guide

An isometric guide will give the Procreate end-user the power to add a 3D perspective to the designs. This is useful to professionals, including architects, engineers, and those involved in technical graphics.

To customize your isometric guide, click on Actions and then Canvas. Then tap on Edit Drawing Guide to open the Drawing Guides screen. Next, tap the Isometric button from the bottom screen to launch the Isometric Guide. You can now adjust the guide from here.

Symmetry guide

The Symmetry guide mirrors the art across several planes to give it mind-blowing effects. You can set or adjust your symmetry guide by launching Actions and clicking on Canvas. Then tap on Edit Drawing Guide to launch the Drawing Guides screen. Go to the bottom of the screen and tap on the Symmetry button. The default is the Vertical Symmetry Guide, which appears as thin lines overlaying the artwork.

Rotational vs. mirrored

Procreate is set at mirror symmetry as a default. You can, however, switch to rotational symmetry. Rotational symmetry will cause anything you draw to be reflected and rotated. Therefore, anything you have created will be mirrored vertically and horizontally

simultaneously. You can turn the rotational symmetry from the options menu in the drawing guide.

Using QuickShape to draw

To draw using a QuickShape, follow the instructions below:

Pick a monoline brush from the brush library

Draw a circle using your Apple pencil without picking the pencil at the end

Lift the Apple pencil and click on edit shape

Open Edit Shape to click a shape option

Draw a square to see its edit shape options

Draw and manipulate your own polyline.

Create a QuickShape

To create a QuickShape, draw a shape or line and hold your finger to the canvas at the tail end of the drawing. The QuickShape will come up automatically after a moment. You will see your stroke snapping into a perfect line, quadrilateral shape, triangle, ellipse, polyline,

or arc. After creating the uneven shape, hold the shape still and also place a second finger on the canvas to create a square from a rectangle, a quadrilateral triangle from an uneven one, and a circle from an oval.

How to edit QuickShape

After releasing your shape, the Edit Shape button will appear in the notification bar. The notification bar can be found at the top of the canvas. Tap on the Edit Shape button to edit, and it will take you to the QuickShape Edit mode. Your initial shape will determine the available edit option. The transform nodes permit precise control and help scale the shapes uniformly.

Chapter 15: The Action Menu

How to insert images and texts

Adding images and texts to your creation can make it look more inspirational. Aside from images and texts, you can also insert files and photographs onto the canvas. You will need to copy the canvas to do this. Alternatively, you can cut, copy and paste separate artwork parts. Follow the tips below to insert images:

Tap on Actions to insert images in PSD, PNG, or JPEG.

Tap on Add

Then Insert a photo

This will activate your Photo app

Check the folders in your iPad for the phone not to be inserted

Inserting PSD using this method will present it as a flattened image

To add text, follow the steps below:

Tap on the wrench button from the top left corner of the screen to launch the Actions menu

Next, tap on Add and then Add text

This will activate a text box on the canvas.

Drag the text box to any position you prefer on the canvas, and you can start typing in it immediately.

You can also change the text color by tapping on the Active Color. The app offers several text fonts; you can access them by tapping the Edit Style button. The Edit Style button will also open the door to several editing options and design tools.

Next, open the Layers panel to start resizing the text editing. To resize the text, tap on the Text layer of the thumbnail. The action will convert the vector text to pixels. You can now apply and affect any Procreate feature to the text.

The series of options make your design more exciting than ever.

How to flip the canvas

Follow the steps below to flip your canvas on QuickMenu:

Enable QuickMenu if not already enabled.

Launch the QuickMenu and look for an open action slot

Assign Flip Horizontally to an open slot and assign the flip vertically to an open slot

Ensure you consistently stay on the QuickMenu setting panel

Activate QuickMenu using the gesture and then swipe the screen in the Flip action direction

Follow the steps below to flip the canvas using Actions Menu:

Launch the Actions menu

Tap on the canvas button

Flip the canvas by clicking on the button. You can do this by clicking on the "Flip canvas vertically" or "Flip canvas horizontally" button, depending on how you want it.

This second method will require a longer period than the first one despite having fewer steps.

Sharing your artwork

Procreate permits end-users to share their artworks in various formats, such as looping animations, bulk images, and PDFs.

To share images, follow the steps below:

Share your artwork in. procreate format by tapping Actions, share, and then Procreate one after the other. Choose a destination for the file to complete the process.

Share your artwork as an Adobe Photoshop file by tapping on Actions, Share, and then PSD one after the other. Choose a destination for the file.

Share your artwork as a PDF file by tapping Action, Share, and PDF. You can also select export quality like Good, Better, or Best. Choose a destination for the export.

Export your artwork as a JPEG file by tapping on Actions, Share, and JPEG one after the other. Then choose a destination.

Export your artwork as PNG by tapping Actions, Share, and PNG one after the other.

Export your artwork as a TIFF file by tapping on Actions, Share, and TIFF one after the other.

Sharing layers

You can share layers in various formats on Procreate, like MP4, PNG, GIF, PDF, etc.

To share layers, click on Actions, then Share. When in the Share Layers section, you can find different layers export formats to use with each of the formats using the layers differently.

PDF: All the layers will export into several PDF pages, with each layer occupying a page. Expect the PDF to have five pages if the canvas has five layers.

Chapter 16: Time-Lapse Videos

Changing the time-lapse settings

To change the time-lapse settings, follow the steps below:

Open the Gallery and check the top right corner of the screen for the plus button; tap on it to launch the New Canvas menu

From the top right menu, look for the two-rectangle icon containing a small plus sign and tap on it to launch the Custom Canvas screen.

Then tap on Time-lapse settings.

You can now modify the time-lapse settings as you deem fit. You can equally change the video's resolution from 1080p to full 4K. It also enables you to change the recording quality settings.

You can easily play, pause or share your time-lapse videos to enable you to control and view your time-lapse video any time you like.

To replay the video, tap on Actions, then video and time-lapse replay one after the other.

To pause, tap on Actions, Video, and toggle Time-lapse Recording off one after the other.

To export or share, trap on Actions, Video, and then Export Time-lapse video one after the other. You can determine the video length to be shared from 30 seconds to a full length. The sharing or exporting can be directed to any app or service connected to the iOS Files interface.

Review and share a time-lapse video

Sharing your time-lapse video enables you to share it with the world. It lets you show your great work to others and let them see your design techniques. It will also get more people to take an interest in your work. You will need to download a video editing app on your iPad to enable you to share the video successfully. The app will help you combine and recut each time-lapse video using music to help you create an impressive portfolio. The video-sharing process uses an algorithm that preserves the important frames in your video.

Altering preferences

You may require advanced knowledge to alter your preferences when handling your time-lapse videos on Procreate. For example, the HVAC is off by default. You can change the video setting to this if you so desire. The HVAC is a unique video compression form for creating advanced motion graphics. Toggling it on is very easy. You can alter the replay settings for your video too. Drag your finger right or left on the canvas to scrub forward or backward while the video replays. You can also focus on details as the video plays by pinch-zooming and moving around the canvas.

Setting the interface appearance

You can modify the time-lapse video quality by following the steps below:

Open the Procreate Gallery

Look for the plus sign and click on it to create a new canvas

Look for the square with a plus printed on it and click on it to create a custom canvas

Indicate the qualities you want for your canvas, like color profile, DPI, dimensions, etc

Launch the Time Lapse Settings by clicking on it. then adjust as required

Create the canvas

Toggles for the interface

The interface toggle options are:

Dark interface: It comes with two visual modes and is an unobtrusive charcoal interface helping you to focus on your artwork. A light interface provides higher contrast in a bright environment.

Brush cursor: The outline on the Brush shape shows up on switching on the Brush Cursor to enable the end-user to see the mark's shape in advance

QuickMenu: You can invoke the QuickMenu by turning it on and tapping the canvas twice. You can also dismiss it by tapping it off.

Projector: It enables end users to connect an external display via AirPlay or cable

Using a third-party stylus

You can connect any third-party stylus supported by Procreate to the app. The third-party stylus can be connected via Bluetooth. Follow the steps below to do this.

Tap on the connect legacy stylus to open the Connect Stylus panel

It will show you a list of the supported stylus for Procreate

A message will pop on the screen before launching the Connect Stylus panel. Tap on OK to continue

Make sure the third-party stylus is on.

Choose your stylus brand and scan for your device.

The Connect Stylus panel will show you options and readouts about your stylus when it finds the third-party stylus.

Chapter 17: Adjustment Tools

Color adjustment tools

Color adjustment enables you to make your artwork look advanced. Some of the available color adjustment tools are:

Hue, saturation, brightness: It enables you to tweak any layer's lightness, vibrancy, and color value using simple sliders. You can quickly achieve color adjustment using HSB. Click on Adjustments, then Hue, Saturation, Brightness, and this will take you to the HSB interface.

Color balance: It changes your hues balance to stylize or correct your color scheme. Procreate combines the three primary colors, blue, green, and red, in different ways to form more than sixteen million color shades.

Curves: It helps you to modify the layer's tonal balance and color using powerful curves in one smooth motion

Gradient map: it helps apply a colorful gradient across images. It analyses the image's shadows, mid-tones, and highlights and replaces them with the colors present in the new gradient.

Uniform transformation

Uniform transformation can move, rotate and scale layers swiftly. It does this without affecting the original proportions of your image.

First, activate Transform. Then touch and drag the selection or layer to move it. You can also touch and drag it anywhere on the canvas.

The uniform mode permits two ways of transforming an object. The uniform mode consistently presence your image's original proportion while transforming the object.

Interpolation process

Interpolation helps to adjust an image's pixels when transformed, rotated, or scaled. The steps include the following:

Nearest neighbor: This is the fastest and simplest interpolation type. It only takes cognizance of one pixel on either side of the edge upon calculating the result of the transformed display.

Bilinear: It considers a 2x2 pixels area surrounding the edge. It also delivers a

weighted average for the four and requires a longer processing time. The result is, however, smoother than in Nearest Neighbor.

Bicubic: It considers a 16 surrounding pixels area and offers more importance to pixels closer to the edge.

The snapping tool

You can align your transformation when you move an object by snapping. Snapping is also useful when re-sizing since it keeps objects in their original proportion.

To activate snapping, tap on the Snapping button and toggle it on. You can turn it off by toggling off.

With the snapping feature on, the blue guidelines will appear on the screen when you transform or move your content. It shows scale or positional points you might find helpful. The contents will then snap to things like items sitting on other layers or center points of your canvas.

Chapter 18: Making Selections

Selection modes

The selection modes are highlighted below:

Automatic: This option works by selecting everything. However, it is possible to change the threshold of the things it selects; drag your finger along the screen to do this.

Freehand: You can draw your selection in this mode. It is a great mode for handling complicated shapes and for those that only need a part of a layer.

Rectangle and ellipse: You can use this option to drag an ellipse or rectangle selection around an object

Add: It eases the process of adding your current selections. You can access it freehand.

Remove: You can use the option to remove any item from the selection and to correct selection shapes.

Invert: It is useful for inverting the selection. In case you have earlier selected an item, you can

deselect it by clicking on the invert, in which case it will select the background.

Copy and Paste: This option enables you to copy and paste any selection to a different layer quickly

Feather: This option helps to soften the edges in your selection. A slider will show up, enabling you to increase or decrease the feathering amount.

Save and load: The option makes it easy to save the actions you use most of the time.

Color fill: It will fill a selection with color. You can use it by tapping the color fill icon until it changes to blue. After that, fill in the color by choosing a selection mode.

Selecting and modifying available options

Interface and gestures: You can isolate any part of your art by using Selections for transforming, editing, repainting, and more. Active selection helps to protect the essential parts of your work, permitting easy transformation, filling, erasing, smudging, and painting. You can easily

undo and redo the selection, depending on your artwork's requirements.

Automatic: It allows you to select and modify your work with a single touch instantly. You can launch the Selection toolbar by tapping on the Selection button. Then tap Automatic. Next, tap any area on the canvas to add the Automatic mode to your selection.

Freehand: You can select using this method by hand-drawing around your desired content. It is an intuitive approach to selection and modification. You can tap to use a polygonal line or draw with your hand to make a freehand selection. You can also combine both and create complex shapes.

Rectangle and Ellipse: It offers a very simple selecting option. It enables elliptical and rectangular selections by simply dragging a shape into place. Launch the Selection toolbar by tapping the Selection button. Next, touch the shape and drag it across the content you want to select.

Advanced: It involves using advanced or robust tools or complex Selections. It enables you to turbo-charge your workflow and ease the work process. The three main options are reload the previous selection, save and load selections, and select layer contents.

Chapter 19: Vanishing Points And Perspective Concepts

You can use adjustable vanishing points to create realistic backgrounds and objects in your artwork. Perspective is easy to adjust as described below:

Click on Actions

Then click on Canvas

Tap on Edit Drawing Guide. The screen for the Drawing Guides will open.

Check the bottom of the screen for the Perspective button and tap on it

To add vanishing points, tap on any point on the screen and create three vanishing points to give you perspectives for one point, two points, or three points. You can then adjust your Perspective Guide by dragging the individual nodes.

One-point perspective: You can also call it parallel perspective, which is the simplest perspective. All the surfaces facing the viewer in the image look like true shapes and bear no

distortion. Distortion only occurs on surfaces traveling away or toward the viewer.

Two-point perspective: It can also be called angular perspective. All the horizontal lines come together towards the two points on the horizon line, with only the vertical lines being parallel. The result is more realistic in this type of perspective.

Three-point perspective: It is the most complex of the three types of perspectives. It is, however, a realistic form. All the lines in this perspective go back toward only one of the three vanishing points, mimicking how humans see the real world. Consequently, it gives the object in the artwork a believable height, width, and depth.

How to draw a simple pencil sketch

You must bear the following in mind when drawing a simple pencil sketch on Procreate

Use only one color

Use only HB pencil for erasing and sketching

Maintain your brush size constantly at 1%

Smudge using shading graphite

Follow the steps below to make a simple pencil sketch

Sketch out the proportion of the item and make a new layer below the outline

Block and hatch in the darkest parts of the arm and head. Do not fall into the temptation of increasing the brush size

After hatching in the shadow, change your brush settings to 10% and leave the pressure at 3% to begin softening and shading the shadows. Consider replacing the stylus with your finger when smudging to add realism and give it a more natural experience.

Use shade size to block in the shirt and use the eraser to cut in some cloth effects. Fine-tune the cuts using smudge

Crosshatch in the shadows of the arms and torso. Do not increase the brush size to avoid losing the necessary sketching details.

After completing the hatch, start smudging and shading in subtle tones. Consider using the

shade brush size at the leg areas since they are not in direct light.

Troubleshooting common issues

Problem:

Change brush size when zooming

Solution:

Tap on Actions

Tap on Prefs

Toggle Dynamic Brush Scaling

Problem:

Unable to locate the previous brush widths

Solution:

As you move the brush slider to your preferred percentage or size, a small box appears. Hold down the slider with one finger and tap on the plus sign. It will save your current brush size.

Problem:

Imported images are pixilated

Solution:

Open a new canvas and change its size as desired

Set its Dots Per Inch (DPI) to around 300

Import photos to the new canvas by tapping on Action and Insert a photo

The photo will appear with that new DPI setting instead of the original one

Problem:

Too many layers

Solution:

Free up your quota by merging multiple layers. Follow the steps below:

Place your thumb on the lowest layer

Place your index finger on the topmost layer

Drag the fingers towards each other

This will merge all the layers from the topmost to the bottom-most

Problem:

Drawing symmetrical designs

Solution:

Tap on Actions

Tap on canvas

Hen tap on Drawing Guide

Select Edit Drawing Guide and apply its settings

You can now draw complex ideas with higher precision

How to solve Procreate constant crashing

Procreate can crash on your iPad because of software updates on the iPad or Procreate app. Using a large canvas can also cause it to crash. Limited storage is yet another possible cause.

To resolve this issue, you should consider updating your app or iPad. You can simplify things by enabling the automatic update. Avoid automatic updates if you are concerned about bugs.

If you had updated the app or iPad, the crashing might be due to a bug in the updated software. Alert Procreate developers about this; it is not possible or risky to roll back to the previous software version.

If the problem is insufficient memory space, delete some unnecessary files from the iPad and app to free up more space. Your iPad must not run on a memory of less than 10%

Chapter 20: New Features Of Procreate

In 2022, Procreate released its latest major update for artists worldwide. Some of the new features make it possible for users to gain the ability to paint directly onto the surface of 3D models. This is because of the new suite of accessibility features, plus access optimizations for M1 iPad Pros resulting in bigger canvas resolutions and even more layers. Some of the new features include;

(1) Proper Organization:

With the Procreate app, you can arrange your work in the art gallery format and get documents from other artists and different devices to arrange your work in a gallery style. You can equally carry out highly skilled modification at the pace of your choice.

(2) Easy to Use:

The Procreate app is one of the relatively simple apps to utilise among other apps that serve the same purpose whether you had an idea on how to navigate through the app before now or not. Moreover, due to its easy-to-adapt

format, you can use the app as an amateur without the help of a tutor.

(3) Colors:

Procreate has a vast range of colors. Unlike normal painting, you do not need to combine colors as different shades of a particular color is readily available for use; in fact, all colors you could think of are made handy, giving you a finer quality of work.

(4) Integration:

This app allows you to add various techniques to your work. In addition, you can move in between apps to source for ideas to make your work better.

(5) Economical:

Procreate is one of the cheapest art software you can get. Many similar apps come at a bill of $100 for initial access to the software and, most often, a monthly renewal fee. However, Procreate comes at the cheap non-renewable rate of $9.99. No higher quality form with extra charges exists. Once the subscription has been

made, that's all. Once in a while, using the Apple account, the app can be upgraded.

(6) Animation:

With Procreate, you do not need to get another app for animation as the app comes with 2D and 3D animation capacity.

(7) Generation of New Brushes

A brush studio is a part of the Procreate software. Even if you are not good at handling the brush, the software will help out. In a situation where you are not satisfied with the brushes you have, you can import brushes from other artists. This is one of the added advantages of using the Procreate app.

(8) Rapid modifications:

You can easily modify your work using Procreate. The tools for modification are all arranged in one bar so that no part of your work is hidden by any tool while it is in use.

How to Install the Procreate Software

1. Go to your Apple play store.

2. Log in by agreeing to the Terms and Condition of the app.

3. Type Procreate in the search space.

4. Tap it and enable install using the blue icon for installing.

5. Press Pay to make your Purchase.

6. Put in your purchase details.

7. Put in your Password to affirm your purchase.

8. The Download procedure will commence.

9. Once the downloading procedure is completed, you can launch the app by pressing its icon.

Supported iPad Model For Procreate

The current version of Procreate is supported on the following iPad models: iPad Pro 12.9-inch (1st, 2nd, 3rd, 4th, and 5th generation), iPad Pro 11-inch (1st, 2nd, and 3rd generation), iPad Pro 10.5-inch.

iPad Accessories for Procreate

Here are some of the accessories that are needed for you to use the procreate app;

Apple Pencil: The Apple Pencil is the best stylus to use on the iPad, especially with the Procreate app. If you're used to writing with brush pens, oblique holders, or even a regular pen, it'll feel strange to start writing with the Apple Pencil because of how sleek and thin it is.

iPad Case: Although the primary purpose of a cover is to protect your iPad from scratches, several designs and features can help you customize your iPad for the purposes you want to use it (digital drawing).

iPad Screen Protector: Writing on glass might be challenging at first if you're a beginner or switching from paper. As you make broad strokes, it could feel as though your Apple Pencil is slipping and your hand is adhering to the screen. The screen protector will help prevent unintentional scratches on your iPad screen.

Artist Gloves for iPad: When drawing or painting on your iPad, your hand will continually be in contact with the iPad's screen while drawing. If your hands are sweaty, this may be a major crisis, making it challenging to hold the Apple Pencil firmly. To address these problems, plenty of artists employ drawing gloves. A good artist's glove keeps your hands dry by absorbing the sweat off your hands. It also lessens friction between your palm and the iPad screen, allowing you to move your hands around the screen without any resistance.

Stable Tablet Stand: It's not the most ergonomic posture to draw on an iPad when it's flat on the table. In addition, it invites fatigue and muscular cramps to use the iPad for an extended time in this position. However, you may arrange your iPad in an ergonomically sound position with the aid of a tablet stand. A particularly pleasant drawing position is on a slightly slanted surface from the back. It eases stress on both your wrists and neck.

Microfibre cleaning cloth: A portable gadget with a sizable screen frequently comes into

contact with your fingers and palms, and airborne dust quickly becomes filthy. The gradual accumulation of oils, moisture, and grime make the screen appear dull and hazy; you could even see the rainbow effect. The screen may be cleaned with a regular cloth; however, doing so needs a lot of rubbing and occasionally force, which is bad for long-term use. You can effortlessly remove all the grease and grime from the screen with a microfiber cleaning cloth, leaving it clean and dry.

Keyboard for iPad: Despite how useful the touch-based iPad shortcuts are, there are still a number of repetitious settings and choices in drawing programs that often need navigating menus and submenus. With the touch of a button, keyboard shortcuts are a convenient method to make rapid adjustments. Investing in a wireless Bluetooth keyboard is a smart move if you frequently sketch on an iPad.

Multi-device Bluetooth Mouse: Many jobs, including graphic design, animation, and vector-based applications, call for a great deal of zooming in and out, clicking on tiny anchor

points, and manipulating point handles. A very useful instrument for this sort of job is a mouse. Get a mouse for the iPad for hands-free navigation.

How to pair your Apple Pencil with your iPad

Different means of connecting your Apple Pencil to your iPad exist. They include:

1. Ensuring the Pencil is positioned over the magnetic end of your Apple device.

2. Uncapping the Pencil and attaching it to the Lightning attachment on the iPad.

3. Connecting via Bluetooth.

Chapter 21: The Procreate Interface

The first component of Procreate is its interface. The first page of the Interface is the Gallery.

Understanding the Gallery Page:

The function of the gallery page include:

Development of new tasks.

Saving of previously completed tasks.

How to create a New Project

Go to the Procreate app.

Open the gallery page and click on New Project.

How to Open Previous Project

After launching the Procreate app, click on the three options at the upper right corner of the screen.

Click on Select. This allows you access to:

Previous projects.

Reviewing tasks before saving them.

Saving tasks on Clouds.

Replication and termination of tasks.

How to Open Photo using Procreate

On the Gallery page, tap the photo feature.

Select your preferred pictures from the photo app which you will be directed to.

A new background that has the selected picture will be displayed.

How to Import Images/Project from Cloud

Simply tap on Import and you will see tasks that are present on Cloud.

How to Create a New Canvas

The plus (+) icon allows for the creation of different kinds of canvas and customizing details such as colors, size of the canva plus other characteristics.

Procreate Main Tools

Main tools are also referred to as Painting tools. While creating projects, you have access to these tools. Main tools are highlighted below:

The Brush Icon

This icon grants you access to where the brushes are. There are two other tools found here that allows you to customize the brushes; Brush size and Brush opacity.

Color Picker: This option is used to select images and even pick colors from images. This icon is found in the middle of the Opacity and Size option.

Eraser icon: With this feature you can alter errors made and modify your design properly.

Color icon: This feature makes it possible for you to choose colors best suited for your design. You can create color palettes, store and share them if you wish. You get to choose an entire mode if you wish to create projects of higher quality.

Layers: Layers option allows you to work on different layers without interrupting the other.

You can modify or erase a layer completely without tampering with other layers previously designed.

Smudge Tool: This feature enables different color combinations and effects in your projects.

Procreate Sidebar

The Sidebar is positioned at the left hand side of the screen. It houses the Size Undo, Redo option among others.

How to Change Brush size

You can increase or decrease the size of the brush by sliding upwards or downwards respectively. The bigger the size the thicker the stroke.

How to Change Brush opacity

The opacity of the brush can be increased or decreased in the same manner as its size.

How to Undo & Redo Changes

Two arrows located with one on top and the other below are used to undo and redo effects

or changes. The top arrow has the Undo effect while the arrow below has the Redo effect.

How to Customize The Interface

The Interface of your design can be customized to suit your taste. You can use either a Light or a Dark theme. It is important to point out that the Light Mode is best for use in very bright areas.

How to Hide Interface

Your Interface can be hidden to allow you to concentrate on the project at hand. To do this you have to launch the Full-Screen Mode by:

Placing four of your fingers on the screen of your device and this will launch the Full-screen mode, thereby hiding the interface.

Repeating the same process to undo this mode.

How to Perform Procreate's Gestures:

Undo gesture: Tap the canvas with two fingers.

Redo gesture: Tap the canvas with three fingers.

Zoom in and out: Place two of your fingers on the screen. Move them apart to zoom in and closer to zoom out.

Rotate Canvas: Move your fingers in a circular manner to rotate the canvas.

Remove layers: Move three fingers to the side to remove layers.

Cut/Copy/Paste: Move fingers towards the bottom end of the canvas to use either of the three features.

Full-Screen: Use four fingers to tap on the screen.

How to Access Quick Menu

Click on Actions;

Then, choose Preferences;

Tap Gesture controls;

Click Quick menu afterwards to view various means of using the Quick menu. The features available in the Quick menu include: Horizontal flip, Vertical flip, Copy, New layer etc.

How to Preview your Works

Saved works can be viewed directly without loading them individually. Simply tap on a work and swipe to view other saved projects; another way to do this is to Click on Preview.

How to Organize Paintings in Gallery

There are three methods of organizing your work.

Dragging: You can drag a particular work until a blue light is shown. Then, you can let it go to form a new folder and rename.

Selecting: Another way of doing this is to choose the projects you wish to save as a folder. Afterwards, at the top of the screen select the Stack option to organise the projects into a folder.

Multi-touch: You can equally add new projects to already existing folders. Simply select the work to be saved in the folder and drag it to the intended folder.

Chapter 22: How To Use Brushes And Colors

This chapter deals on how to make use of brushes and the color feature to create fabulous designs.

How to Modify and Save Color

Various types of color exist in Procreate. There are different color options available to ensure that you get the best as it relates to colors.

1. Active color: These are colors that are constantly being used. They are located at the tip of the color section at the right side.

2. Secondary & Primary colors: There are two blocks that show these colors. To the right, there are the secondary colors while to the left are the primary colors. These two blocks are below the Active color panel.

3. History: Just like any other app with the History feature, these features display the colors that have been used in order of when they were used with the most recent on top. You can clear out your Color History by clicking on Clear.

How to Create New Color Palettes

Procreate allows you to set up as many color sets as you wish in a Palette. The Palette is located at the bottom of the color panel. Here is how to go about creating color set:

Go to the Palette.

Tap the (+) icon to form a new palette.

How to Access Brush library

Tapping the brush icon opens the brush library. The library houses the brushes. It is located at the right end of the screen.

How to Organize the Brush Library

To organize the various brushes in your library;

Slide down the Brush set area.

Tap to create a folder.

Rename the folder.

Drag the preferred brushes to the newly created folder.

Type of Brushes

There are about 18 kinds of brush sets which include:

Sketching Brush: For crafting designs.

Drawing Brush: For creative drawing.

Inking Brush: Inking brushes are designed to give the natural brush pen feel. They are thick in texture except for the Tinderbox brush set.

Calligraphy: For the creation of specially crafted letters and art.

Painting: For painting.

Artistic: For the creation of different kinds of effect.

Abstract: For creation of special effect shapes.

Organic: For the creation of natural elements like plants.

Other brushes include Vintage, Spray-paint, Touch Ups, Water, Luminance etc.

The Brush Studio

The brush studio serves the function of managing the features of the brush like its size.

To create a new studio, click on the (+) icon at the top of the brush library.

How to Duplicate Brushes

Procreate allows the replication of brushes except for custom brushes. The process of brush replication is as follows:

Press the Duplicate icon at the left side of the brush area.

How to Import Brushes

To import brushes, drag the brush from its initial location to where you want it to go.

How to Rename the brushes

To rename the brush folder double tap and select the Rename option.

Chapter 23: How To Use Layers

This chapter will teach you how to utilize the different layers that are present in the app.

Layers Panel Interface

The interface format for the layers is such that all the features are all arranged in a panel. There are 8 features present;

Layer menu: This feature allows you to launch Layers.

Create Layer: This feature is for the creation of a fresh layer. It is represented by the (+) icon.

Thumbnail: This allows you to view the content and details of a layer.

Blend mode: This mode is used to combine characters and contents of different layers.

Visibility checkbox: This makes it possible for you to view the details of a layer individually. To enable this, tap and hold the visibility checkbox over the layer of interest for some seconds.

Background layer: This makes it possible to edit and customize the background layer of a project.

Organizing Layers: This makes it easy to arrange and sort for completed tasks.

Selection of Layers: This feature helps you to work on many layers at once. You can carry out commands such as deleting, editing etc on a number of layers at a go.

Primary layer: For each work, there is a single primary layer and numerous secondary layers. The default color of the primary layer is brilliant blue. You can simply tap on a layer to make it a primary layer.

Secondary layer: The default color of the secondary layer is deep blue. Swipe to the left of any layer you want to become a secondary layer.

Grouping layers: Putting a layer into a group is possible with Procreate. Just choose the layers you wish to group and tap the grouping menu.

Moving Layers: This allows you to move in between layers. First, have the completed tasks arranged. Then, select layers, drag them to where you wish them to be. Then, slide them up or down to move them.

How to Use the Quick menu

To launch the Quick menu, you can;

1. Double tap your finger or Apple Pencil, or

2. Swipe a layer to the left.

3. Quick access has the following options:

Alpha lock: This feature allows you to seal the effects done in a particular layer. This way painting can be done within the confines of the layer. To access this feature, use two fingers to swipe to the left.

New layer: You can create a new layer with ease using the Quick menu.

Medium Nozzle: This is used to paint a number of thick layers.

Merge Down: This is used to merge two layers into one.

Delete Down: This feature makes it easy to choose layers that are beneath the selected layer.

DK Watercolor: This displays watercolors.

Chapter 24: How To Add Text In Procreate

This chapter is aimed at explaining how to add texts to artwork, styling, font importation using different means etc.

How to Add Text

Click on the Action section.

Click on Add Text.

A text box will appear for you to write your text, click on Ok or done and the text will be added.

How to Edit Text

Tap twice in the text to be edited.

Modify the text. You can make use of features such as Copy, Paste, Align etc.

How to Resize Text Box

Press the blue nodes.

Drag the nodes to either enlarge or reduce the size of the text box.

How to Edit Text Style

This feature allows you to add special and customized effects to your text including style, font etc.

Font: A lot of fonts exist on the app. Simply tap your preferred font to apply it.

Style: This feature indicates the different ways a font can be used. When you select a particular font, at the style area, the different pattern the font could be in is displayed.

Design: With this feature, you can decide the opacity, size, format of your work. You can equally apply the Tracking feature that alters the spacing format of your work all at once, or the Kerning effect that has its effect on the space between the letters of your work singly.

Attributes: This feature is used in aligning, capitalizing, outlining and underlining the texts in your work.

How to Import Fonts in Procreate

The ways to import fonts include;

1. Import Fonts from Edit Style:

At the right of the screen, click on Import after inserting your text and choosing your preferred editing style.

Go to the folder where your fonts were stored in Files.

Click on your choice font and it will be imported to the Procreate app.

2. Import Fonts by Drag and Drop: To do this, go to the app where the font to be imported is present. Click on it and drag it to the Procreate app.

Chapter 25: How To Use Action Menu

This section of the manual explains the utilization of the Action menu. The duties

performed by the action menu will be highlighted.

Using the Actions button

Six sub-sections of this component of the app exists;

Add: This allows you to attach pictures, text, documents to the background of your work. Further actions that can be carried out include: Copy, Paste of your work.

Canvas: This allows for the modification of size, inversion, of your work.

Share: This segment is used to share your painting in various forms (GIFs, MP4s, JPEGs, and PNGs).

Video: This section makes your painting animate and equally allow you to preview what you have done.

Prefs: The mode of your interface as well as other changes can easily be effected according to your Preference (Prefs).

Help: Here you can source for info on how to manage the app, get in contact with the customer service and have access to the community page.

How to Insert Images and Texts

You can insert a file, a photo or take pictures directly using the inbuilt camera which will be saved as a layer.

How to Add Private layer

Private layers function as standard layers but for the fact that they are not displayed in the gallery when previewing. This layer does not reveal details that have been excluded from the final painting. To enable this feature, shift the option to insert the file to the left.

How to Add Texts

In the Add section, there is the Add Text feature. Click on this to type in your text and add the text to your design. You can make use of Active colors to change the color of the text or carry out other forms of modification using the Edit Style option.

The Canvas

This gives specialized info as regards your canvas. Added functions such as a painting aid exist as well.

How to Crop & Resize Canvas

This allows you to modify the shape and size of your canvas. The Crop and Resize feature is employed to carry out this function. When you tap this function, it will place a grid over your design, making it possible for you to adjust the design to your taste.

Animation assist and Drawing guide

These features help you maximize motion design and the Procreate app as it provides help in carrying out special effects.

Referencing:

Reference is a feature that enables you to handle more than one task at a time. It shows the mini picture of the canvas and is movable by being clicked and dragged to the chosen location.

Reference canvas

Reference canvas shows you the content of your canvas while you are doing something else. The reference companion allows you to either delete or add an image to your work.

Reference image

This is used to get images that are not found in the reference. You can revolve the images, and pick suitable colors with the aid of the eye dropper.

Reference face

The Reference face uses special technology to paint the content in a canvas on the face. To enable this feature, tap the Face icon. You need a FacePaint canvas to use this feature.

Flip canvas:

The Flip Canvas is used to move the canvas either in a vertical or in an horizontal manner.

Canvas information

Canvas information gives comprehensive specialized data as it regards your artwork. The info captured in this feature are as follows;

About this artwork: Here, your work can be displayed. You can sign up your name, signature and a picture of yourself. This way, whenever your work is viewed from the app, your details will be seen as the owner of the work.

Dimensions: This gives you info on the physical size and measurement of your work in inches, pixels etc.

Layers: Layers contain information on the quantity of layers present in your work and the maximum number of layers that you can add.

Assisted/clipping/masks and groups

These give you information on the number of groups present in a work, the quantity of layers that are being aided by Drawing assist, those assigned as Clipping masks and the quantity of them that are present.

Color profile: This shows the color chosen during the course of creating the work.

Video settings: This shows the length of motion graphics created. Other information include:

1. Video quality – Adjusting the settings for the video will improve the visible quality of the video but will equally lead to an expansion in size, which will in turn affect the storage space, downloading/uploading speed.

2. Video resolution - The higher the resolution of your work, the higher the quantity of pixels present.

3. Video size – this gives you details on the size of the video which is influenced by the duration, quality and resolution of the video.

4. Video codec - A codec is a kind of video reduction style used by the video doc.

Statistics: Here you get details such as the amount of strokes, size of the video.

How to Share your artwork

Your paintings can be shared in a standard pattern. Six of these patterns exist.

1. Procreate: This format ensures that all the details and content of your design including your "About the Design" is intact when being shared to another user. If you happen to enable the video recording of your work, this can be accessed by a user too.

2. PSD: This will share your file to another user in an Adobe® format. This means that from your blend styles, level of opaqueness, visibility and more will be intact and accessed by another user. This is best for a situation where the partner of whom the file is being sent to does not have the Procreate app.

3. PDF: This is a quality enhanced form of sharing your design. It is best suited for sharing your work digitally.

4. JPEG: This format reduces the size of the file but reduces its quality as well in the process. However, it is the easiest and commonest image document sharing format because of its smaller size.

5. PNG: PNGs are similar to JPEGs in operation. It reduces the size of a document

(though it's still larger than that of JPEG) and still manages to retain its quality.

6. TIFFs: This is a format used to produce documents in enlarged forms. It is used mostly in prints.

How to Share layers

Sharing of Layers can be done in 6 different layouts; PDF, PNG, Animated GIFs, MP4, PNG, HEVC.

How to Create a Time-lapse video

The natural set up of a fresh design background is the time-lapse video. For good quality, the resolution of the video is set at 1080p. Note; this feature can only be modified at the commencement of a project but not in the middle of it.

How to Change the Time-Lapse Settings

Launch a fresh canvas by pressing the + button at the top of the screen of the gallery page.

Afterwards, tap an icon of 2 rectangles and a little + sign to open the Custom Canvas screen.

From the menu that appears, choose Time-lapse to modify the settings of your canvas.

Modify the video quality from a resolution of 1080p to 4000p.

How to Review and Share Time-lapse Video

You can review your work directly from the replay option of the time-lapse video. This way your work will be replayed continuously at a rate of 30 frames per second. You can simply move the video to the left or right, zoom in and out as well. When you are okay with seeing the video, press done to go back to your artwork.

How to Share time-lapse video

Sharing of the time-lapse video is enabled by going to the setting of the video and pressing the export time-lapse video option. You get to choose to either send a full video or a shortened 30 second version of the video. The shorter version is compressed, nonetheless, contains the valuable contents of the video.

How to Disable time-lapse video

Time-lapse can be disabled on selected layers by tapping the time-lapse option. To disable it completely from everywhere, this has to be done on the settings of the device.

How to Adjust Preferences

Go to prefs on the Actions feature to adjust preferences. This includes the Brush Cursor which shows the shape of the brush, light or dark mode etc.

Chapter 26: Transform Tools

Transform tools are used to enlarge and change areas that have been selected. This tool comes in the form of an arrow located at the top of Menu.

How to Use the Bounding box

The bounding box is moved in circular motion to enable a user to position the content on a canvas better and can give the zoom in effect.

Transformation nodes

Transformer nodes are anchor points that are blue in color positioned at the ends of the bounding box. This makes it possible for you to maximize the utilization of selection.

Bounding box adjust node

Beneath the Selection icon is the Bounding Box Adjust Node which is yellow in color. It makes the reposition of content in a canvas possible.

Snapping

Snapping enables you to align your transforms properly while dragging it. Tap the snapping symbol to enable the effect.

Rotation node

The Rotation node enables you to rotate your content at a particular point. This node is located at the top of Selection and its icon is represented by green color.

Transformation methods

These are the means of modifying the shape and size of the content. These methods include distort, warp and uniform

Flip: For flipping of content either vertically or horizontally.

Rotate: For bending content at an angle of 45°.

Fit to screen: For fitting a canvas to the size of the screen.

Interpolation: Interpolation is a technique for adjusting the pixels of a whirled, measured, or changed image.

Choosing this feature will produce either of these 3 options; Nearest neighbor, Bilinear, Bicubic.

How to Reset Changes

Press Reset to undo certain effects done in Transformation.

The Different Transformation modes

Freeform: This allows you to compress or enlarge your Selection and not maintain the initial proportion.

Uniform: With this you can rotate, and move the layers of your artwork while keeping to the measurement of your initial picture. Other modes include magnetic, distort and warp modes.

Node control

Pressing a node allows you to control your movement. It could be to the front, middle or to the back.

Chapter 27: Adjustment Tools

Adjustment tools are used to improve the quality of artwork with wonderful visual effects. Pressing the magic wand icon breaks the adjustment interface into two:

1. Adjustments: This has to do with color manipulation and modification. There are a few tools that are available for color adjustment. The upper tool bar of the app is reserved for this purpose.

2. Filters: This is created to add special effects to a design. There are about 11 kinds of filters. Filters can be applied in two ways; one as a Pencil, the other as a layer.

Color adjustments tools

1. Hue, Saturation, Brightness (HSB): Hue is the main color of the work while saturation deals with the intensity, and brightness, the level of brightness.

2. Color balance: This is used to create a beautiful blend of the colors giving it a balanced feel. Primary and secondary colors are beautifully combined.

3. Curves: Curves is a highly skilled technique. It involves a balance between HSB and color balance. It is used to modify layers and contrast.

4. Gradient map: This is used to add a gradient map to your work. This function by changing the schemes of the color used. The different schemes available include: Blaze, Breeze, Instant, Mocha, Mystic, Neon, Noir, and Venice. Personalized schemes can be created as well.

How to Use Filters

The 11 different filters that exist are highlighted below:

Gaussian blur: Evening a layer with a blur.

Motion blur: Creating a false motion effect by adding a blur.

Perspective blur: Generating a zoom effect by adding a radial or semi radial blur.

Noise: Production of a grainy effect.

Sharpen: To increase the sharpness of your design.

Bloom: Adding of brightness or glow to a design.

Glitch: Adding a distortion feel to your design. It has four modes; artifact, wave, signal, and diverge.

Halftone: Production of a grayscale effect to a painting.

Chromatic aberration: This gives a two-way effect to your artwork. Perspective gives a chromatic aberration radially from a main center and Displacement is used to apply the effect vertically or horizontally.

Liquify: This twists your layers in several fascinating ways. These include push, pinch, twirl, expand, edge, construction, and crystals.

Clone: Replication of a design and positioning it in a different location.

Procreate Tips and Tricks

This chapter covers a number of tips on how to maximize your Procreate app.

How to Draw with Quick shape

Quick Shape helps to produce a better drawing of geometric shapes e.g. rectangle, triangle etc.

How to Make Perfectly Equal Shapes

After drawing, put your finger on the screen to enable the Quick Shape feature and put your finger on the screen again to make the shape drawn to be perfected.

How to Scale & rotate

To scale or rotate, place your finger on the screen of your work and move it according to where you want it to go.

How to Activate Animation Assistance

Launch the Actions menu.

Press the sub-menu on the canvas.

Enable Animation Assist to activate it.

How to add Background

Go to Frame.

Press Background switch.

How to Use Quickline for Straight, Continuous Lines

Suppose you are finding it difficult to draw straight lines, you will find this tool to be of great assistance. Simply draw a line, curve, or circle, then release your Apple pencil while keeping it pressed to the screen. The lines you have drawn will then be "stabilized" or polished by the program.

How to Add Layer

Layers are a feature that may help you keep organized and provide a professional touch to your artwork. Press the "+" symbol next to the layers panel to add a layer. By swiping left on the layer you wish to modify, you may access other choices for that layer, such as delete, lock, and duplicate.

How to Use Blend Mode

The different layers and features you use for your art design can become too visible and

affect the overall general view of the artwork you are designing. Blend mode comes in handy to interact with several layers. By pressing "n," you may access blend modes in each layer. The default blend mode for all layers is "N," or normal mode. After enabling the blend mode, you can customize further by selecting different options such as darkening, brightening, managing layer opacity, and much more.

How to Use Alpha Lock:

When you want to create shadows, highlights, and patterns without going outside the lines previously created, this option is useful. Suppose you want to add extra details to a layer after you've drawn on it, press on the layer's picture and choose "alpha lock" from the layer's menu. Any details you add after the image has been "locked" will stay inside its original frame.

Printed in the USA
CPSIA information can be obtained
at www.ICGtesting.com
LVHW011143211023
761740LV00012B/883